IMAGES
of America
SWEET HOME
IN LINN COUNTY
NEW LIFE, NEW LAND

IMAGES of America

SWEET HOME IN LINN COUNTY
NEW LIFE, NEW LAND

Martha Jane Steinbacher

Copyright © 2002 by Martha Jane Steinbacher.
ISBN 0-7385-2069-1

Published by Arcadia Publishing,
an imprint of Tempus Publishing, Inc.
Charleston SC, Chicago, Portsmouth NH,
San Francisco

First Printed in 2002.
Reprint 2003.

Printed in Great Britain.

Library of Congress Catalog Card Number: 2002105522

For all general information contact Arcadia Publishing at:
Telephone 843-853-2070
Fax 843-853-0044
E-Mail sales@arcadiapublishing.com
For customer service and orders:
Toll-Free 1-888-313-2665

Visit us on the internet at http://www.arcadiapublishing.com

CONTENTS

Acknowledgments		6
Introduction		7
1.	The First Settlers, Farming the Land	9
2.	Mining and Logging	25
3.	Travel—From Horses to Airplane	43
4.	Learning and Worship	63
5.	Who Were They?	85
6.	From Hunting to Music	95
7.	Places to Remember	105

Covered Bridge Map 123
Mining Map 124
1893 Postmaster Map 125
Sweet Home Map 126
"The Fir Has Claimed Its Own," by William Mealey 127
Lost Prairie Monument 128

ACKNOWLEDGMENTS

The East Museum Society would like to thank all of the people who have bestowed their trust in the museum by donating thousands of their most precious memories in the form of these wonderful photographs. The museum has a photo, portrait, and postcard collection exceeding 2000 images, as well as some additional glass plates and negatives. The museum also has on file numerous original documents, works by early historians, and other written accounts which provide an abundance of information about pioneer families and early life in East Linn County.

I would like to thank Alex Paul, owner and editor of the *New Era* newspaper, for helping reproduce some of the photos selected for this book. Gail Gregory provided invaluable assistance in selecting the photos. As volunteer curator for the Museum she will be left with the large task of re-filing those photos plus the many additional ones which we sorted through to make our selections. Glenda Hopkins scanned the photos and typed the text for submission to the publisher and Jess Barr provided much technical information in answer to my questions about farming and farm equipment.

We gratefully acknowledge Mary L. Poitras, Deana Campbell, Jess Barr and the Keith Gabriel estate for the loan of their personal photographs when we discovered that some photos were missing which we considered important to include in a history of the Sweet Home area.

This book project has been enlightening to all of us who worked on it. To create a sampling of life in a small western town with only a few pictures is a challenge—a very enjoyable challenge. I hope readers will enjoy the book as much as I have enjoyed writing it.

<div style="text-align: right;">
Martha Steinbacher
Local historian
Former Director of East Linn Museum
</div>

INTRODUCTION

Escaping persecution for their Mormon beliefs, a small group of family and friends were led westward by Lowell Ames to Oregon Territory. Crossing the High Sierras, they wintered at Diamond Springs, 40 miles east of Sacramento, California. From Sacramento they traveled by boat to Portland and then up the Willamette Valley searching for a new home and a new life. At Brownsville they headed east over Fern Ridge and down into the valley below. They reached the banks of a small stream known now as Ames Creek, crossed, and set up a camp calling it "Paradise Camp" or "Pilgrim Camp." They were impressed with the little valley and decided to settle there. Lowell Ames and his sons took out donation land claims on acreage that is now Sweet Home. Other families settled on "The Road to Zion," now called Clark Mill Road. More families came close behind them and spread out across the beautiful valley. The Andrew Wiley family settled at the base of Whiskey Butte on Wiley Creek. The Pickens brothers settled along the Santiam River near Foster, and the Gillilands settled at the east end of the valley.

The Calapooia and Santiam Indians roamed the valley. A fort, built on Fern Ridge, was never needed, however, because the Indians proved very friendly and helpful to the settlers. Both tribes were part of the Kalapooian Family which occupied the Mid-Willamette Valley. The Santiam River was named after Chief San-de-am and the Calapooia River was named for that Indian tribe.

Those early days were difficult; trading posts were nearly a hundred miles away. Most of the settlers arrived with very few provisions and had to be self-sufficient. The forest, with its abundance of wood, plants, and animal life provided the materials needed to build homes, furniture, and other necessities. It supplied fuel for fires, meat for the body, and peace for the soul. Small trading posts in the communities gave housewives a chance to trade their farm produce of bacon, ham, lard, cheese, butter, and eggs for other necessities. Some settlers arrived, set up make-shift dwellings, then the men headed for the Indian wars or the California gold fields, leaving wives and children to survive the best way possible.

More wagon trains found their way up the Willamette Valley, settling in Brownsville, then Crawfordsville, Holley, Fern Ridge, Santiam, Waterloo, and eastward to Foster and Cascadia. To the north, Kees Precinct was settled in 1848, later called Pin Head and now known as Lebanon. The Jeremiah Ralston family, having arrived in 1847, paid $30 and a yoke of oxen for some squatters' rights, and by 1848 they had set up a trading post. As the smaller settlements grew, grist mills were built, saw mills were set up, and schools were started. Young women graduated from the eighth grade and started teaching. They married, and gradually the small communities were bound together by family relationships and the distances between them diminished.

In October 1846, an unidentified gold prospector discovered gold flakes in the sands of Dry Gulch, but the California Gold Rush created more interest, so it wasn't until 1863 that Jeremiah Driggs filed the first legal claim in the Quartzville area. A wagon road was built and the area became known as Quartzville. A few months later gold was discovered in the Blue River Mining District of the Calapooia. Within three years 1000 people were living in the Quartzville area and there were over 500 mining claims. A red light district called Bryant City was started below Quartzville, but after six years the communities were dead, not because of a shortage of gold but because the inefficient mills were unable to make the operation profitable. Near the present Sunnyside Park the "Greenhorn Bar," so called for the many California greenhorns who came there, was prospected but also failed. The miners tried to use the same methods on the fine Santiam gold that they had used on the coarse California gold, sluicing it into the river, and the gold was lost.

Meanwhile, Andrew Wiley had been watching the Indians pack up in the spring and head east into the Cascades. He figured that they must have a trail on which a wagon road could be built, connecting the mid-Willamette Valley with eastern Oregon. Wiley and a group of friends searched, could not find the trail, but did succeed in building the Cascade Wagon road. In 1865 it became the Willamette Valley and Cascade Mountain Wagon Road, now part of US Highway 20. In a trans-continental race, Dwight B. Huss drove the first car, a 1905 Oldsmobile, over this toll road on his way to the 1905 World's Fair in Portland. The gatekeeper, never having seen a car, charged him 3¢, the fee for hogs.

In 1911 Louis Hill Sr., the railroad magnate, and W.P. Davidson bought every other section of land on both sides of the wagon road from Albany to Ontario, Oregon. They split the property in 1913 and Hill retained ownership from Albany to Sisters. Hill Timber still manages these holdings under the stewardship of Cascade Timber Consulting. In 1932 the first modern saw mill was built in Sweet Home. More mills followed as the timber industry expanded. In 1946 Willamette Valley Lumber Co. made a deal with Hill Timber to build a Sweet Home mill which would process logs from Hill property. This was Willamette National, later to become Willamette Industries. With the influx of mill workers and their families, housing needs grew, as did the number of schools and churches. By 1951 the corporation of Santiam Lumber, Willamette, and Hill had 850 employees.

The reservoirs created by Green Peter and Foster Dams in the 1970s provided new resources and tourism was courted. As the timber industry declined, Sweet Home looked to nearby skiing, hunting, fishing, and gold mining, seeing value as an outdoor recreation center. New ways of looking at the land have given new life to this little community nestled east of the Willamette Valley.

One
THE FIRST SETTLERS, FARMING THE LAND

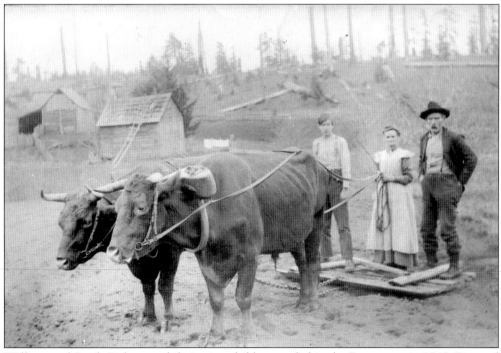

William and Sarah Pickens and their nine children settled in the Foster area in 1847. Pictured here are Orlando, Burressa, and Martin Pickens. Orlando homesteaded 180 acres on the Sunnyside Slope in 1897. His well-trained team of oxen was very special to him, but misfortune struck when the barn roof collapsed after a heavy snow storm and killed them.

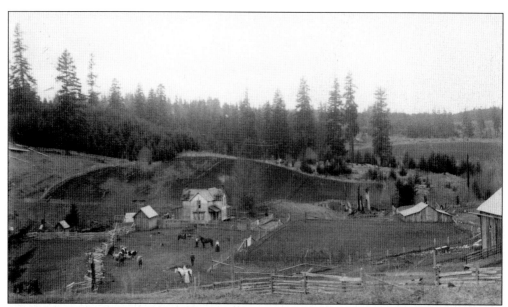

This farm was purchased by Asher Hamilton in 1910, a pioneer who had arrived in the area in 1873. The barn had been built by Albert Riggs and Homer Rice in 1906. Hamilton later sold the farm to a man by the name of Crocker.

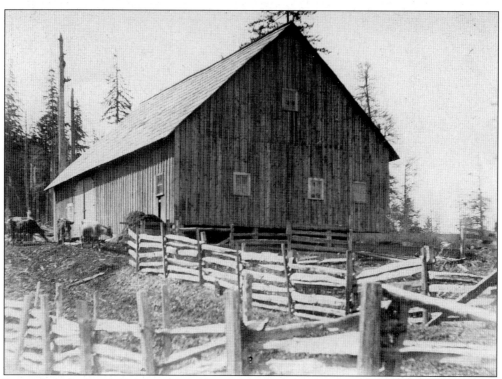

Located on the South Santiam River bottom, this barn belonged to Albert and Maude (Lewis) Riggs. The creation of Foster Lake caused many families to move to higher ground. Riggs Hill is named for the Riggs family.

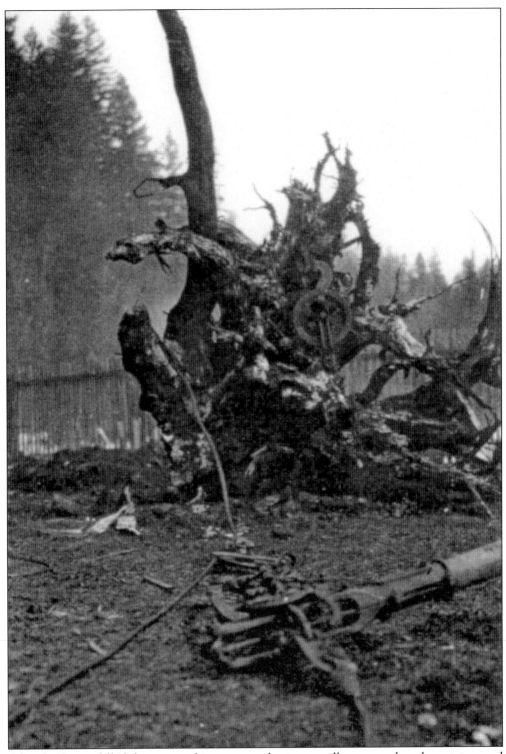
After the farmer felled the trees on his property, the stump puller was used to clear pasture and fields. Gordon Short, a settler in the Cascadia area, owned this particular stump puller.

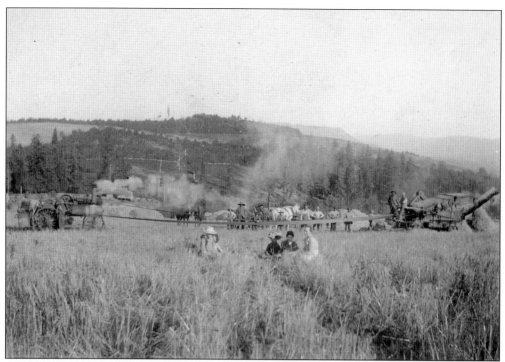
Jim Green farmed in the Greenville Valley, located half-way between Holley and Sweet Home. By 1851 farmers were having equipment shipped from New York by boat.

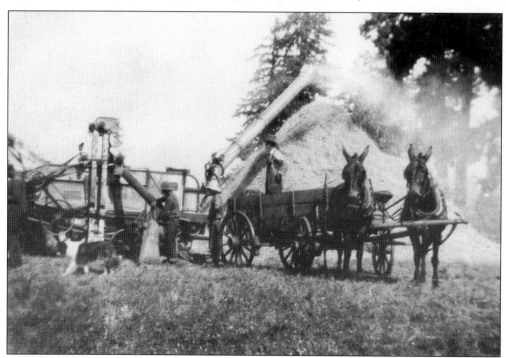
Threshing the new crops was a time-consuming job, even with the new equipment and horses. Jim Green is seen here threshing at Greenville.

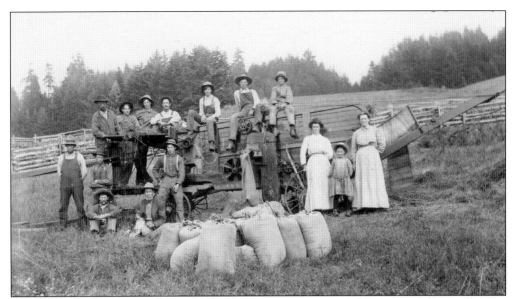

It took eight men—one driving the header, three wagons with drivers, two men feeding and tending the threshing machine, one tying wheat bags, and one at the straw rake to harvest a field in the early days of farming.

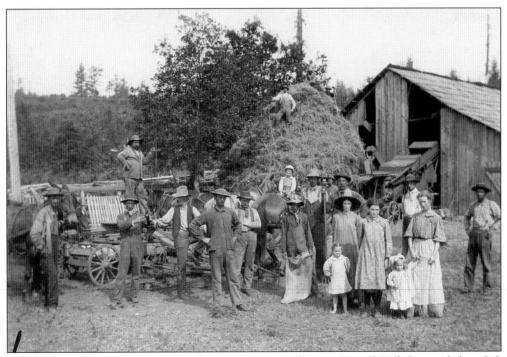

This was threshing time in 1908 at the Frank Malone place on Rowell Hill. Pictured, from left to right, are Mack Moss, John Hamilton, Marion Barr (on machine), Ed Hughes, Jess Moss (on horse), Guy Malone, Lyle Cross, Bill Thompson, Lonz Leach, Verna Moss, May McCoy, Ada Malone and Olga Malone, Charlie Hamilton and Frank Malone (behind the women), Jess Green, and Bob Green and Paul Dawson (on hay stack).

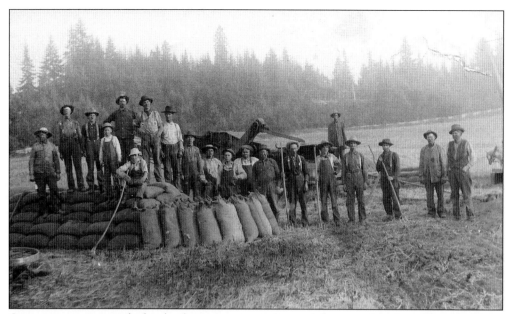

Oats were grown mainly for the farmer's own stock; any left over might be sold to the livery barns in town. A half day's work and a good crop resulted in about 2900 sacks of oats. Some early settlers also rolled their own oatmeal.

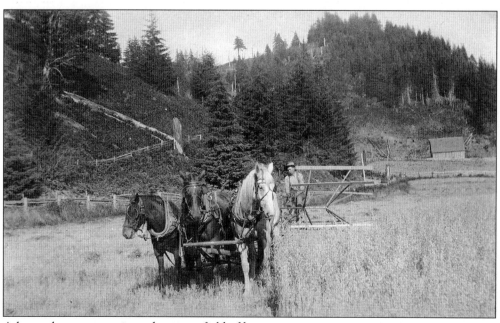

A horse-drawn mower is used to cut a field of hay.

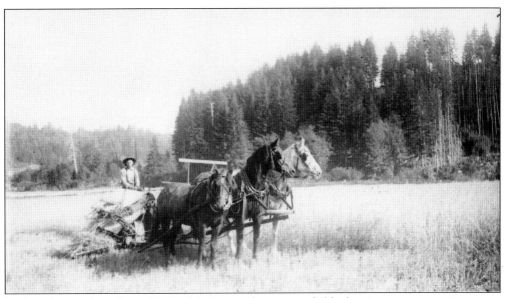
In this photo a three-horse binder is being used to mow a field of grain.

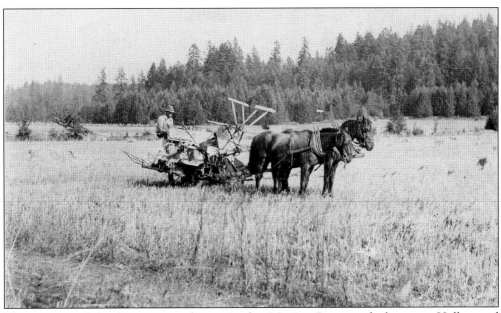
This team and binder were working on the Marion Barr ranch between Holley and Crawfordsville in 1915. The ranch was later owned by Jesse Barr. (Courtesy of Jesse Barr Jr.)

J.R. Springer did the first grafting of fruit trees on his farm on Springer Road up the Calapooia River from Holley. He was also a dairyman and gave singing lessons.

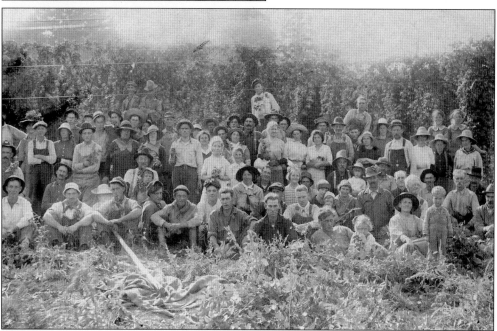

Hop picking was a source of income for the Warm Springs Indians who came across the Cascades in large bands to pick hops at 25¢ a basket. While the women picked, the men competed in horse races with the farmers, then sold the horses before returning to the reservation.

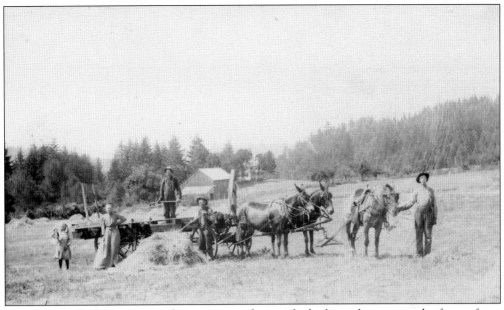

This picture of a hay wagon and crew is part of a mural which can be seen on the front of one of the town businesses in Sweet Home.

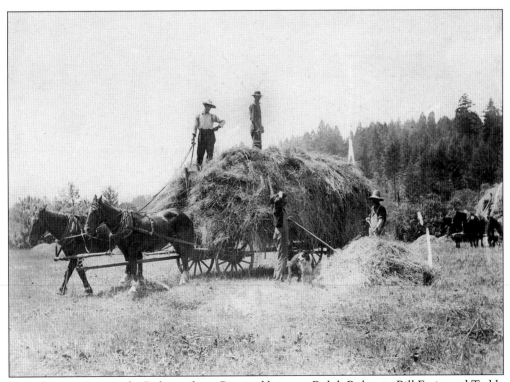

It was haying time on the Robnett farm. Pictured here are Ralph Robnett, Bill Fruit, and Teddy Hinkle with unidentified neighbors. Teddy Hinkle was a German orphaned artist befriended by the Robnetts.

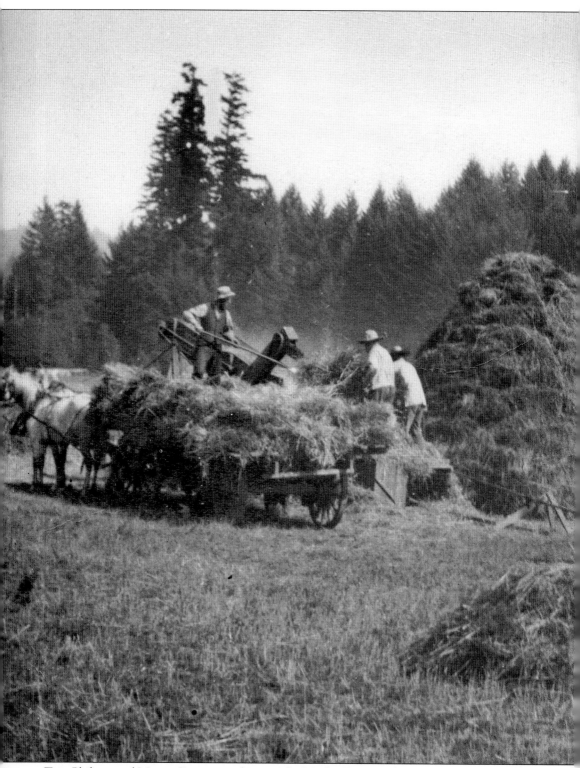
Tom Philpott and Marion Barr are working on the Mealey Farm up the Calapooia River in 1902.

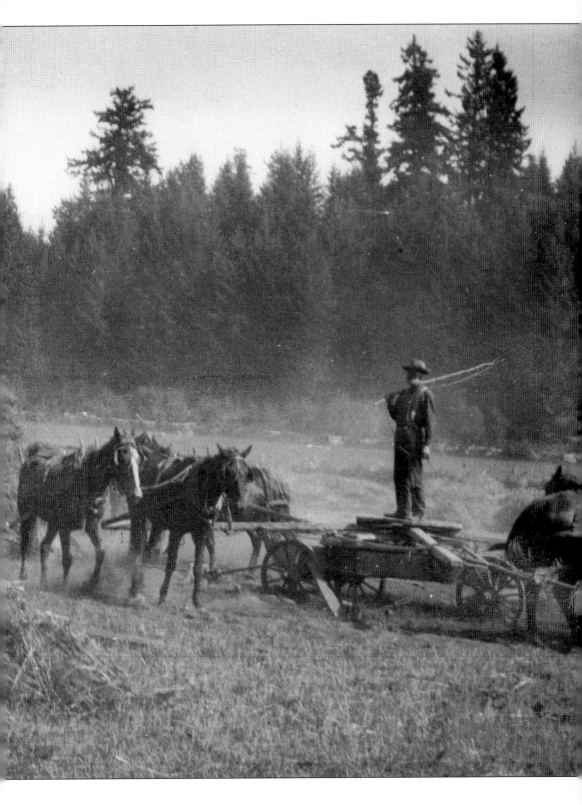

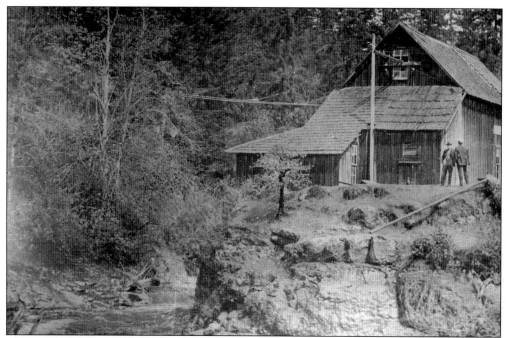

This is the back view of the Foster flour mill, built in 1882 by Mr. Doty. This picture was taken after the dam washed out about 1912, when it was owned by the Wodtli family.

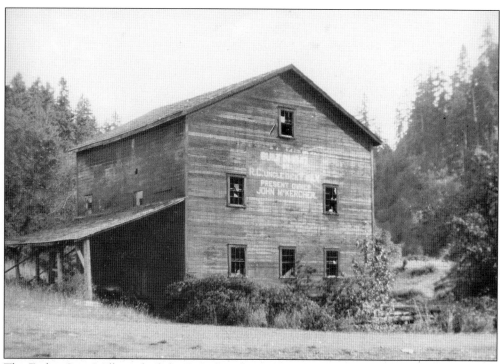

The Finley Grist Mill was built by R.C. (Uncle Dick) Finley in 1847 and later owned by John McKercher. It was located on the falls below present-day McKercher Park on the Calapooia River.

The Marion Barr farm was located between Holley and Crawfordsville. (Courtesy of Jesse Barr Jr.)

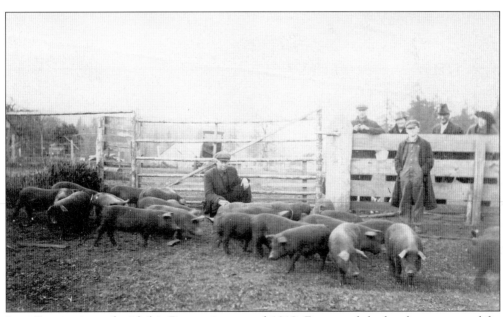
Jesse Barr is pictured with his Duroc pigs around 1918. Farm stock had to be transported for market to Halsey by wagon on corduroy roads, 14 miles away. (Courtesy of Jesse Barr Jr.)

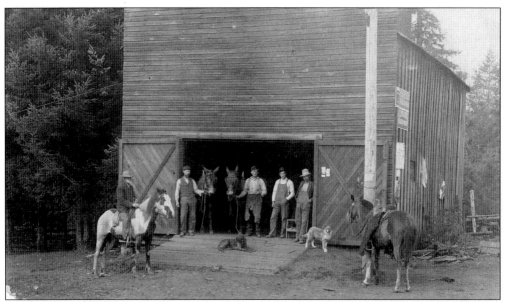

Every small community had at least one blacksmith shop. This is Homer Rice's blacksmith shop in Holley. Pictured, left to right, are Asher Hamilton (riding Old Duke), Justin Philpott, Ivan Murphy, Verge Rice, and Homer Rice. The upper floor of the blacksmith shop was used for a dance hall.

Another picture of Homer Rice's blacksmith shop shows Asher Hamilton's house and Cochran's barber shop in the background. Pictured, from left to right, are Verge Rice, John Sterling, Plez Robnett, Charley Edwards, Charley Hamilton, and Harley Hamilton.

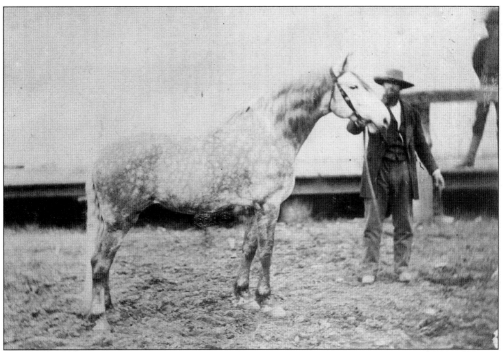

This was the first blooded stallion to be brought to the valley. Norve Rice traded the patent on his butter churn for some horses in Idaho.

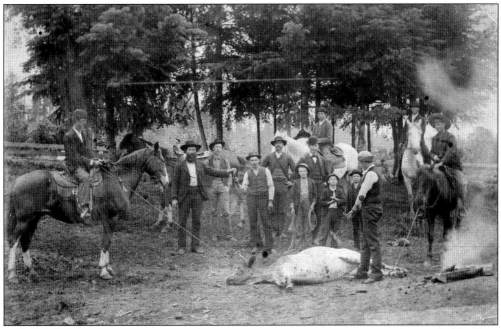

An important part of ranching was branding. Norve Rice's branding crew shown here, from left to right, were Art Moss (holding the branding iron), Mack Moss (on the left horse), Jim Keeney, Black Harry Watkins, Frank Malone, Bud Morris, small boys, Jess Moss, Clyde Rowell, and Bill Putnam. Homer Rice is sitting on the horse to the right.

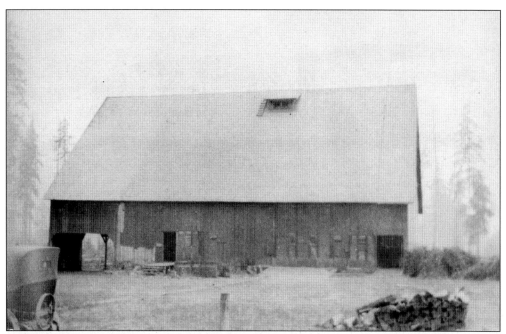

The King Barn was built on the Old Holley Road by David and Rutha King. This was a well-segregated barn: horses on the left, cows on the right, and hay in the top. (Courtesy of Deana Campbell)

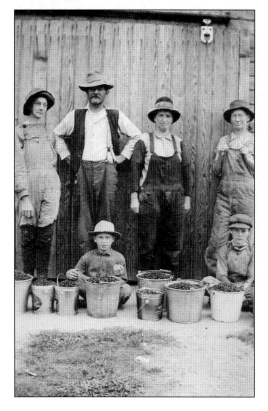

Blackberries grew wild and were a large part of the income for many early settlers. In this 1917 photo, blackberry pickers are Rutha and David King, Lulu Smeed, Mrs. Harris, and children Cletus Rice and Lydia Harris.

Two
MINING AND LOGGING

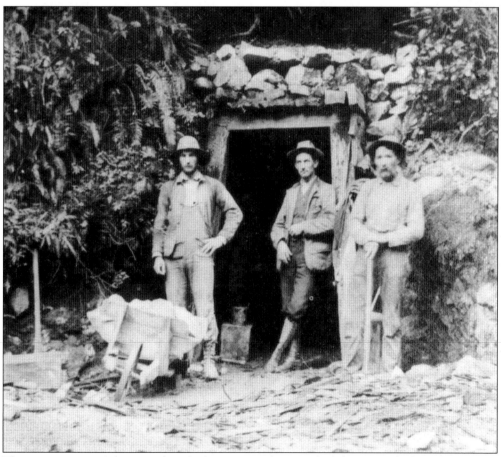

This is a picture of three unidentified miners at the portal of the main shaft to the Paywell Mine in Quartzville.

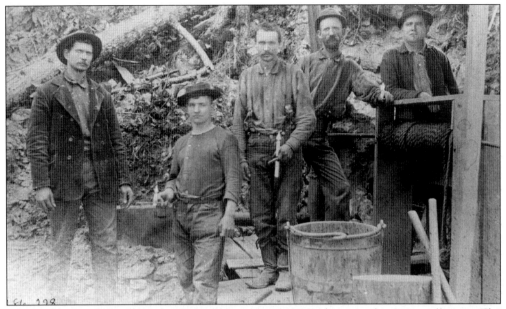

This is the shaft entrance to the Red Bull Mine, one of 500 claims in the Quartzville area. The large bucket on the right was used by the miners to ride down the shaft.

Because the owners of the Quartzville Mining area were very straight-laced individuals, a red light district where miners could go for relaxation was developed below the mining area. This was the Bryant City Hotel in 1930.

WHITCOMB, CASCADIA, FISH LAKE & SISTERS STAGE

Stage Leaves Lebanon Tuesdays, Thursdays and Saturdays at 7 a.m. Leaves Whitcomb and Cascadia Mondays, Wednesdays and Fridays at 7 a. m. Arrives in Lebanon 3 p. m.

Fish Lake and Sisters Stage Leaves Cascadia Wednesdays. Leaves Fish Lake for Sisters Thursdays. Leaves Sisters Fridays and Arrives at Cascadia Saturday Afternoon

GEORGE B. WHITCOMB, PROPRIETOR

This was the posted schedule for the stagecoach which ran between Lebanon and Cascadia, with side trips to Quartzville.

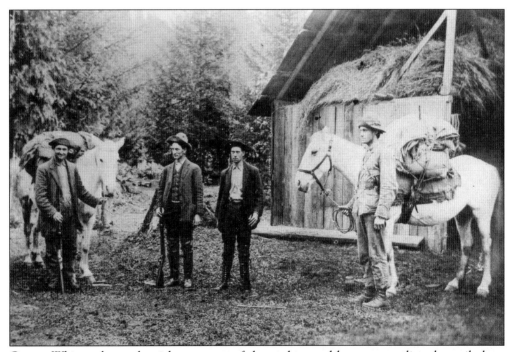

George Whitcomb, on the right, was one of the packers and hunters traveling the trail along Quartzville Creek between Whitcomb and Quartzville. This picture was taken in the early 1900s.

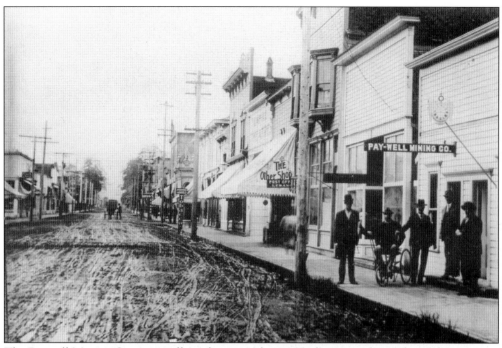
The Paywell Mining Company office, shown in this 1905 photo, was located in Lebanon.

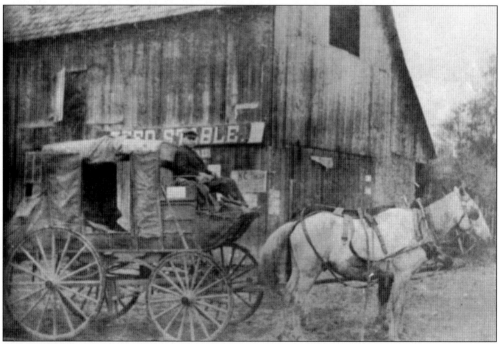
George Whitcomb operated a stage coach for the miners between Lebanon and Whitcomb via Sweet Home. From Whitcomb they walked several miles upriver to the mining area.

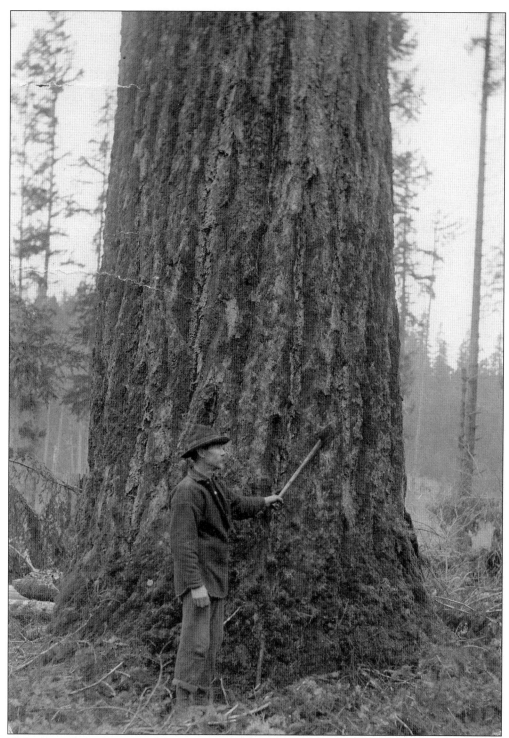

This photo shows the size of the trees which were logged during those early days. This was Jim Wilson's logging operation on the Mohawk River. Although it was more than a 20 mile walk or ride, many Sweet Home men worked at this site.

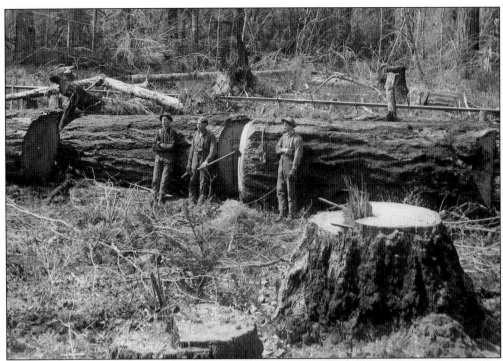

This is a 1911 photo of early loggers Jasper Russell, Frank Pickens, and Wayne Menear. J.C. Banks, pioneer teacher and early photographer, took many of the local pictures.

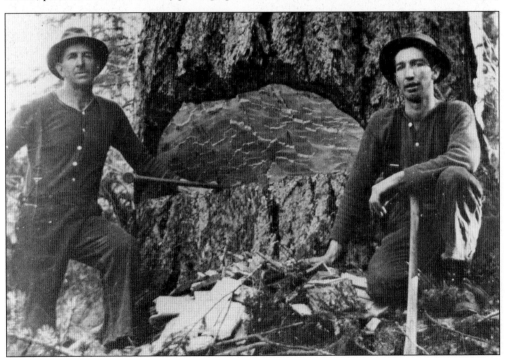

Wayne and Virgil Menear, father and son, show off the size of a cut on a Douglas fir tree which they are felling. (Courtesy of Mary Poitras)

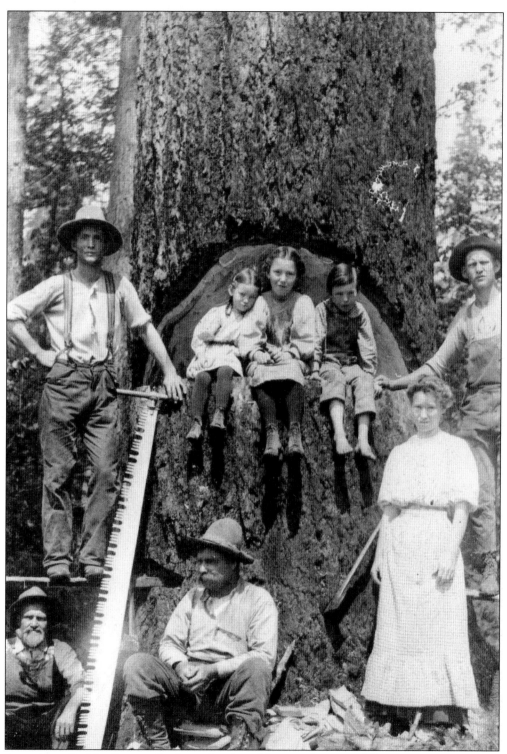
An unidentified family proudly shows the size of the tree they were felling.

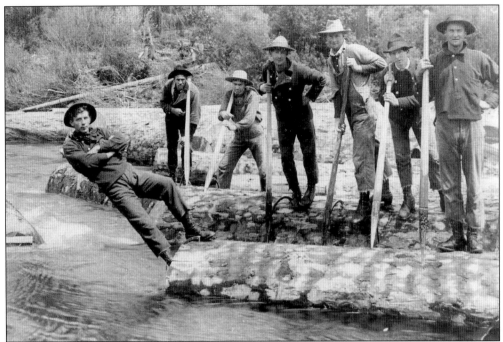

A logging crew drives logs down the Santiam River on their way to Scoggins Lumber Mill in Lebanon. Logs were dumped in the Middle Fork, South Santiam, and their tributaries during high water in the spring and floated down river. The bark on these trees, sometimes a foot thick, was removed before transporting them to the mills.

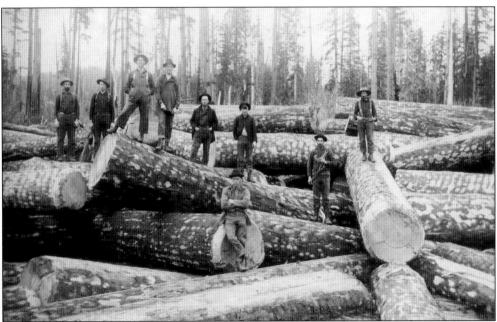

Logs cut by a Scroggins Logging Company crew up the Calapooia River above Holley could be floated down river by the use of splash dams during periods of high water. Later a railroad was built to Dollar Camp on the Calapooia and logs could be hauled out throughout the year.

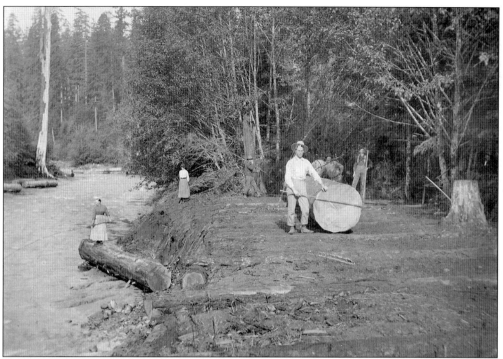

The Wilson logging operation was located on Wiley Creek above Foster. Todd Abrams, a log scaler, is shown in this picture. On the left are Bell Wilson and Grace Kimbraugh, in the background are Harley Kimbraugh and Jim Wilson.

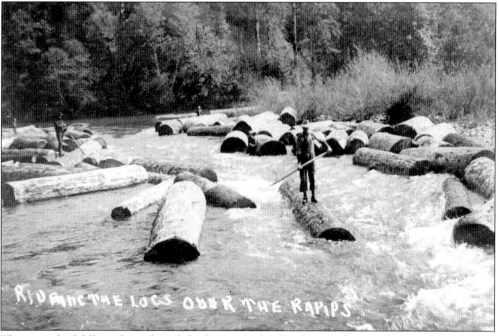

The rivers had falls and rapids and the loggers had to be alert at all times for log jams. This is a scene on the South Santiam in the early 1900s.

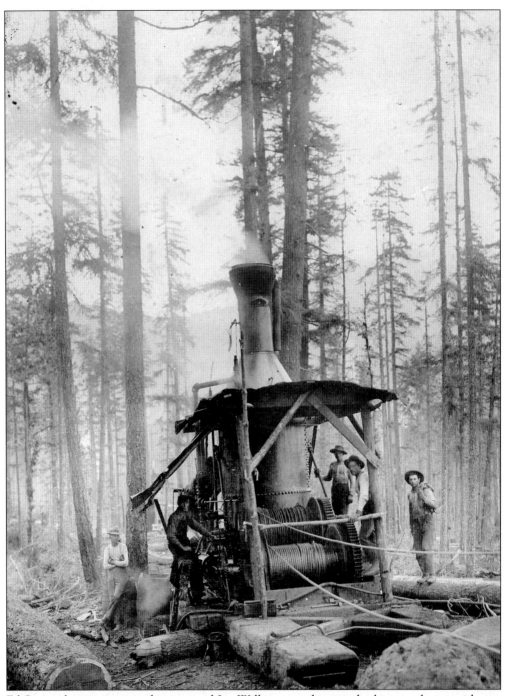
Ed Storey, leaning against the tree, and Jay Wilkins, standing on the log, are shown with one of the many steam donkeys used in the woods.

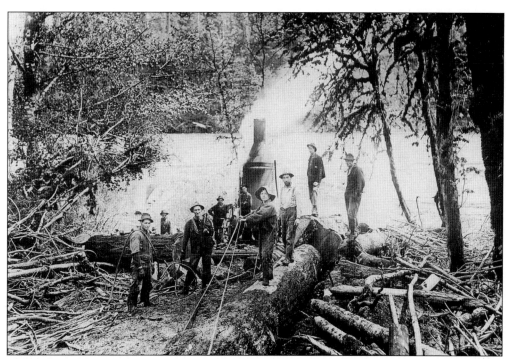

Jack Alberson, Clyde Sloan, Percy Banta, Will Newton, John Newton, and two unidentified men prepare to take logs across the river. The Newtons logged in the Marcola area and up the Calapooia, where John Newton lost his life.

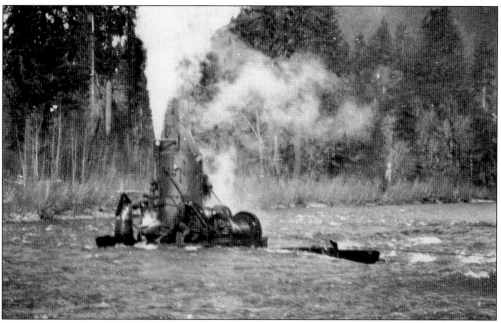

The Mealey brothers had a mill on the South Santiam River at Foster. They used a steam donkey, operated by Thomas Starr Mealey, to haul logs to the mill. This picture was taken in 1909: the mill burned three years later, in 1912, but was soon rebuilt.

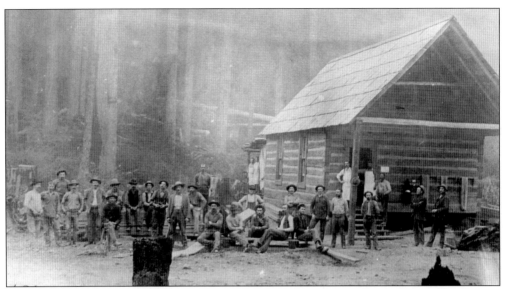

The Dollar Camp was a logging camp located about 7 miles up the Calapooia River from Holley. The building shown here was the cook shack, usually bossed by a woman whose husband was one of the loggers.

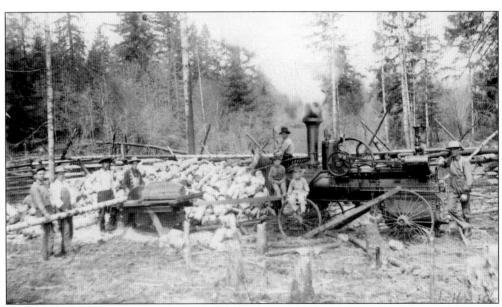

Wood, which was plentiful, was used for heating and for cooking. With his crew, Homer Rice went wherever he needed to cut the year's supply of firewood. Pictured here, from left to right, are Ross Hughes, Glenn Rice, Homer Rice, and Dick Finley; seated are Ernest and Walter Rice; and standing in front of the engine, which he owned, is Norve Rice.

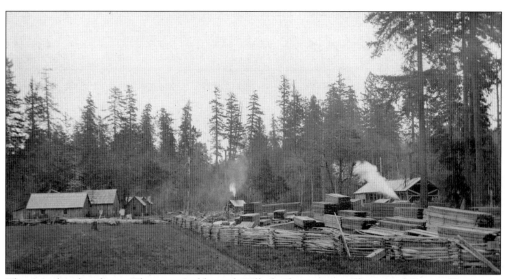

The Mealey brothers, Thomas, Judd, and Bill, built a saw mill east of Sweet Home on Quartzville Road. It was in operation from 1907–1924 and employed seven men. This photo was taken in 1910, two years before the mill burned and was rebuilt.

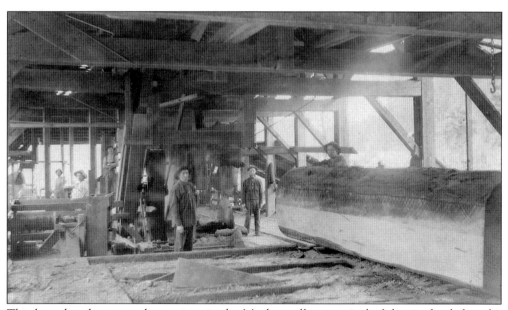

This large log shown on the carriage in the Mealey mill was typical of the size hauled to the mill. Hiram Pickens, born in 1869, and head sawyer at the mill, had been the first child born in the valley.

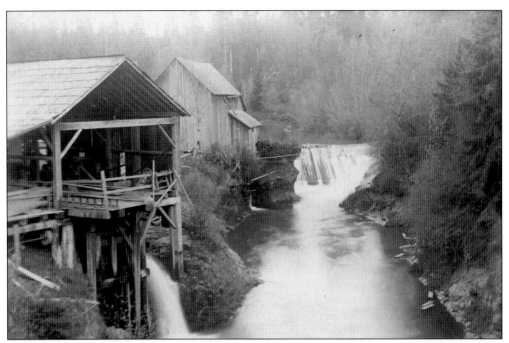

The Wodtli mill, built in 1890 by Parley J. Foster, was later owned by Sanford and Doty, then by Yost and Daugherty. In 1895 Hans Wodtli purchased the saw mill and the flour mill. He supplied electricity to Sweet Home and Foster for $1.00 a month, charging 75¢ more for extra electricity. When the citizens of Sweet Home angered him, he cut off their electricity and supplied only Foster.

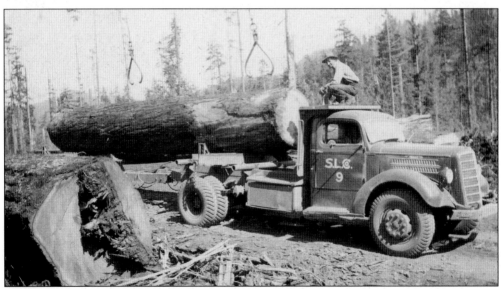

In 1935 Carl Davis and Fred Powers bought the Rice Mill in Sweet Home and renamed it the Santiam Lumber Company. They purchased some timberland and logged what is now the southeast corner of Sweet Home. This is one of their early trucks. (Courtesy of Mary Poitras)

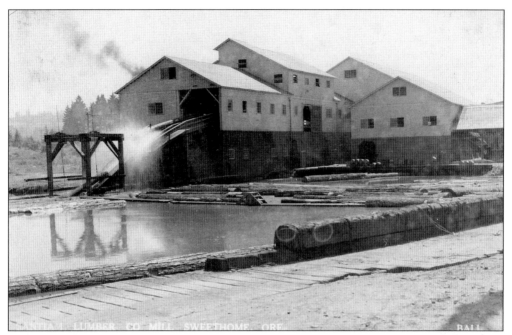

The Santiam Lumber Mill was completely modernized in 1946, but burned down that same year. Insurance money enabled the owners to rebuild. (Courtesy Keith Gabriel estate)

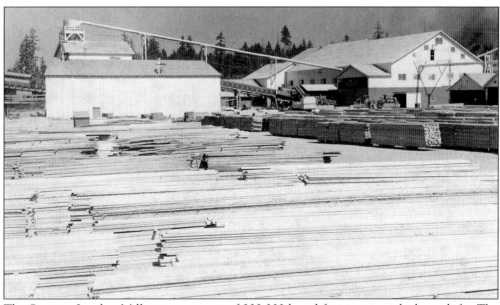

The Santiam Lumber Mill cut an average of 300,000 board feet in two eight-hour shifts. The company employed 670 men, working in the mill and in the woods, and had a monthly payroll of $235,000 for nine months of the year. Winters closed the woods and the mill. Slabs, sawdust, and planer shavings were utilized to generate electricity and to supply fuel for home heating. (Courtesy of Keith Gabriel estate)

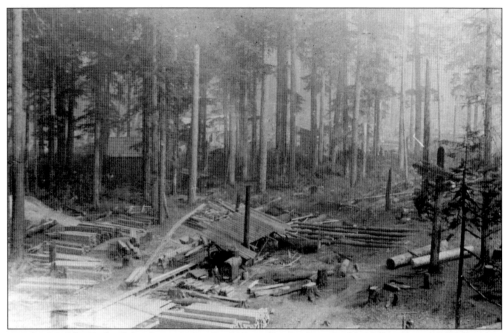
On the Middle Fork of the Santiam at the 500 road, Mr. Crawford built his Quartzville Lumber Mill. This was one of numerous mills which dotted the country side in the early 1900s.

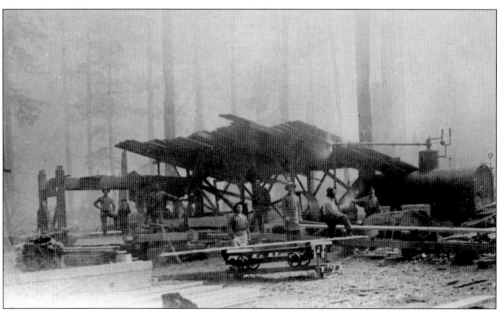
This is a close-up view of the Quartzville Lumber Mill.

Willamette National opened on May 23, 1947. The total operation included a sawmill, planing mill, dry kilns, 60-acre storage pond, shipping shed, machine shed, and a retail building materials store. In 1967 several large mills incorporated to become Willamette Industries.

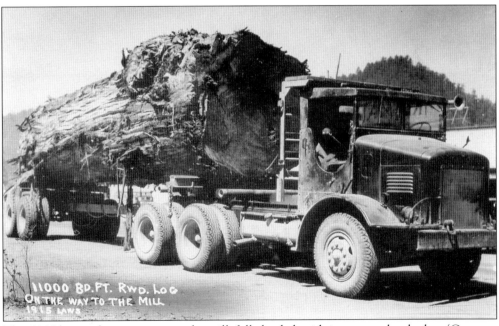

This 1915 log truck is on its way to the mill, fully loaded, with just one red cedar log. (Courtesy Keith Gabriel estate)

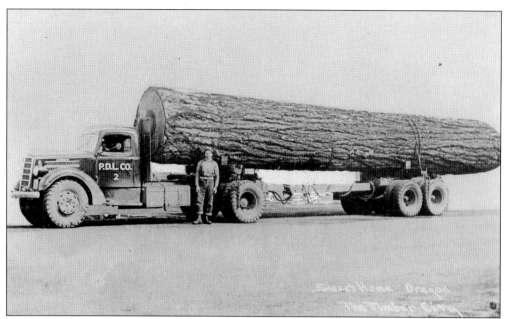

A Power Davis Lumber Company log truck in the 1930s could handle only a single log. (Courtesy Keith Gabriel estate)

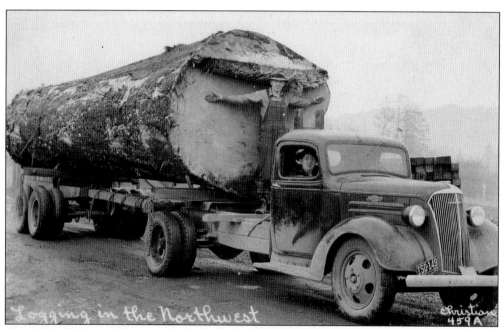

This 1936 Chevy log truck was typical of the log loads traveling through Sweet Home. In 1975 the Sweet Home Jaycee's sent a single log weighing 47,000 lbs. to the national Jaycee Convention in Florida. It was 7 feet in diameter, 32 feet long, and contained enough wood to build a three bedroom house. It was sold to the Fun City Jaycees of Ft. Walton Beach, Florida, and displayed at a local park. A cross-section of this log is displayed at the East Linn Museum. (Courtesy of Keith Gabriel estate)

Three
Travel—From Horses to Airplane

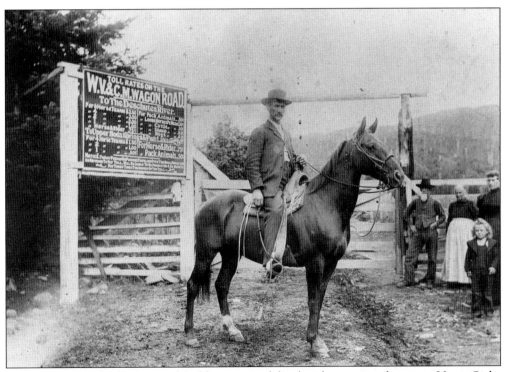

There were several toll gates on the old wagon road, but best known was the one at Upper Soda, now known as the Mountain House. Marvin Nye, pictured here at the toll gate, was one of the better known toll gate keepers.

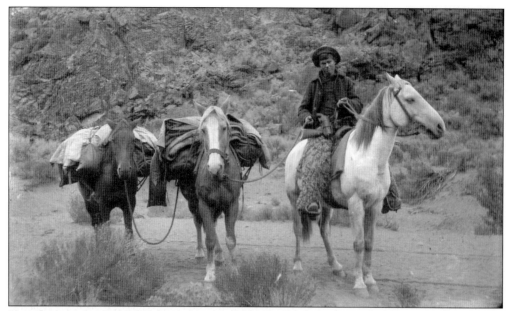

Travel across the Cascade Mountains was difficult. Cattlemen raised cattle and horses on the east side, then drove them to the west side for sale. Peddlers used the road to get to the Willamette Valley. Pictured here is a typical rider with his pack horses.

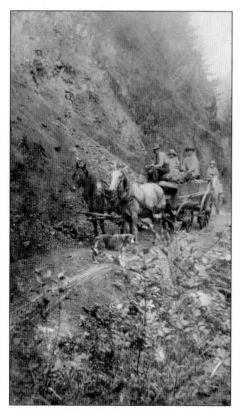

Pictured here is Frank Robnett and his party on their way to Upper Soda, a favorite vacation spot for camping and drinking the soda water.

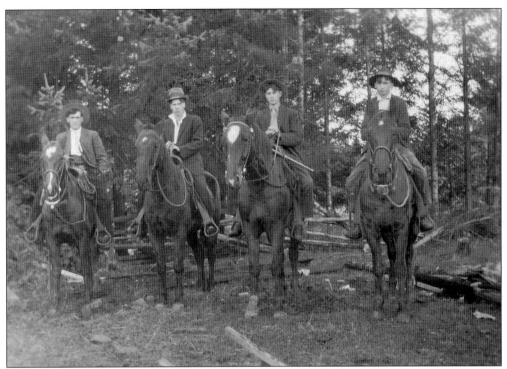

Horses were, of course, an important mode of transportation. The riders are Justin Philpott, Wilkie Morris, Orin King, and Vern Philpott.

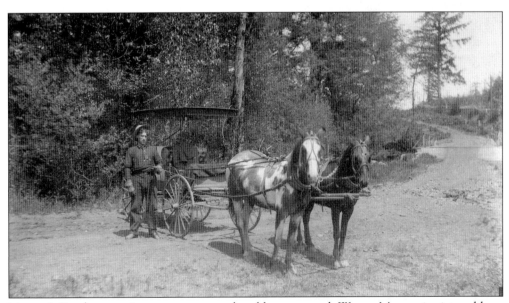

Menear's Bend was an important stop on the old wagon road. Wayne Menear is pictured here at the bend in the road. (Courtesy Mary Poitras)

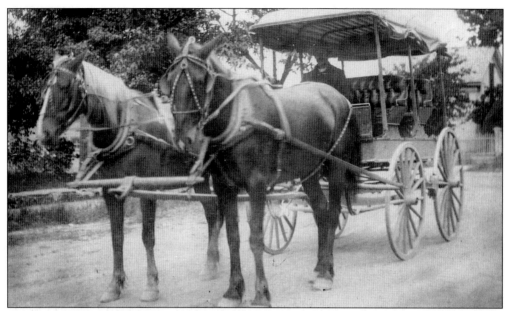

The 1915–16 mail stage between Brownsville and Sweet Home was driven by Ed McClun, a Holley pioneer. His horses were named Dan and Doll. Everette (Ed) McClun was the Holley postmaster during the 1920s and 1930s.

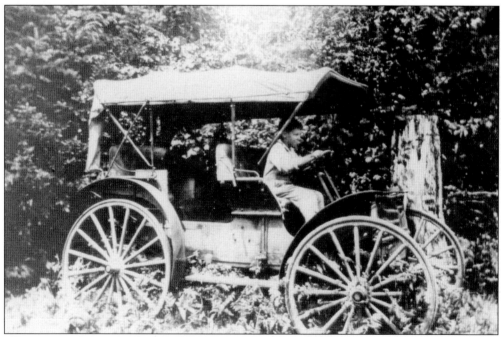

This motorized stage coach, owned by Ernest Billings, ran from Lebanon to Cascadia on the old wagon road. He paid $1,000 for the stage and sold his 160 acre timber claim to pay for it. The run was a 64-mile round trip and took a full day to complete.

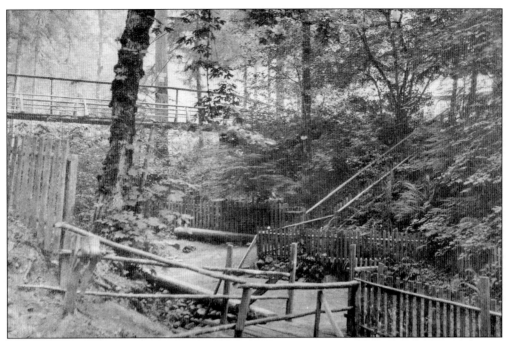

This is a view of Soda Springs in Cascadia in 1903.

In 1898 George Geisendorfer built a 30-room hotel with a barn for 80 horses at Cascadia. The soda springs, known for their medicinal benefits, were the main attraction. Entire families camped for the summer on the spacious grounds, drinking the waters to cure all manner of ailments.

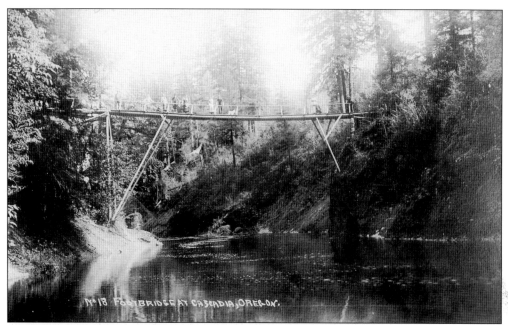

In 1913 this footbridge stretched across the Santiam River at Cascadia.

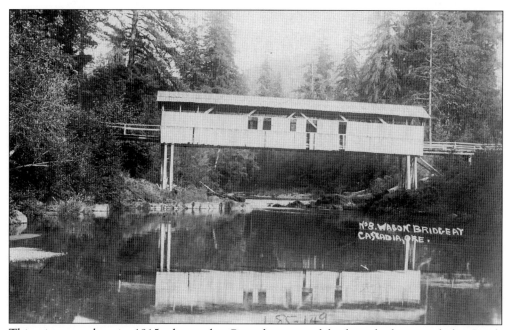

This picture, taken in 1915, shows the Cascadia covered bridge which crossed the South Santiam River. The bridge was built prior to 1904.

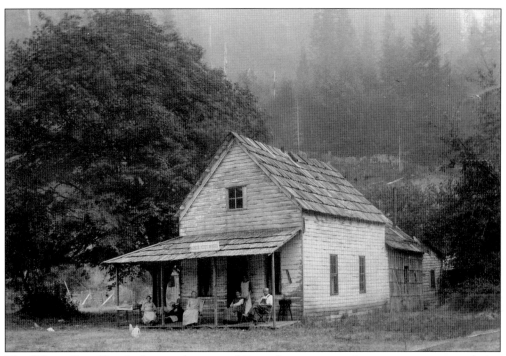

The White City Hotel, three miles east of Cascadia, was one of many stage stops and also served as a toll gate for the Santiam Wagon Road. It later came to be known to many as the Mountain House.

Many Sweet Home men worked from the Cascadia Ranger Station in the Santiam National Forest during the early 1900s. The Ranger station, shown in this 1930 photo, was located 4 miles east of Cascadia, 16 miles over a rough, muddy road from Sweet Home. Not the best assignment!

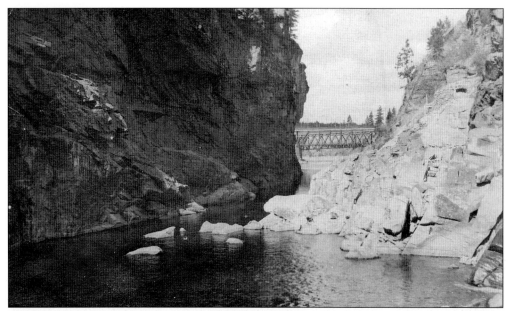

The first bridge at Holley was built by William Matlock who settled in Holley in 1851. The bridge was upstream from the present bridge crossing the Calapooia River.

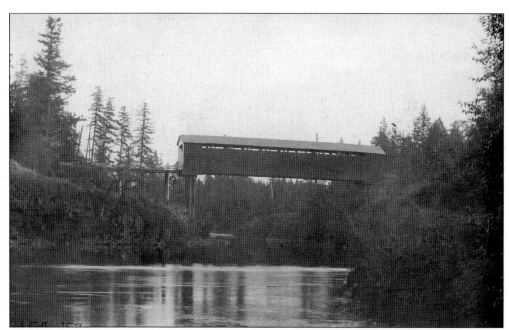

Pleasant Valley is across the Santiam River from Sweet Home. This bridge was the only way to cross the river for the many families who settled on the north side of the river.

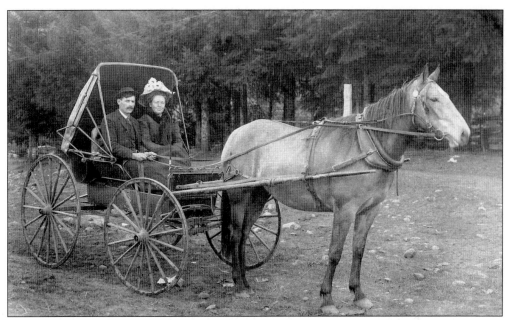
This is a 1915 postcard picture of Frank and Stella (Malone) VanEpps, Holley residents.

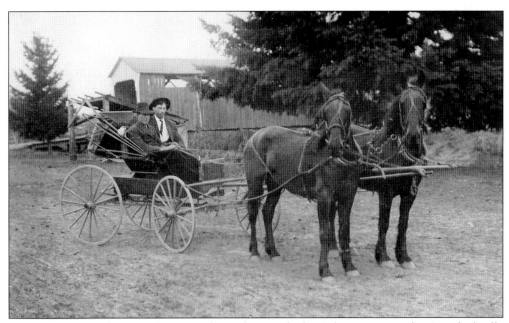
Cleve Philpott and Jesse Splawn are shown here with the Splawn team at the Crawfordsville covered bridge.

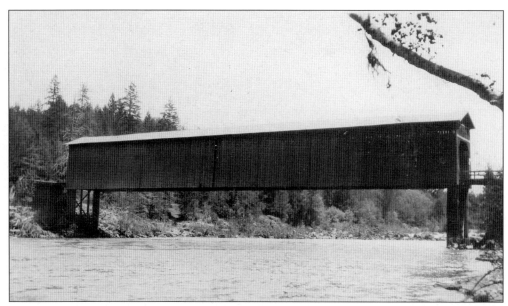

Waterloo was a small village on the Santiam River northwest of Sweet Home. The Waterloo covered bridge was the only bridge crossing the Santiam between Sweet Home and Lebanon.

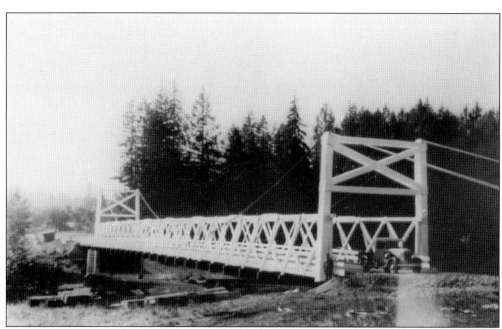

This suspension bridge at Waterloo marked the final stop for the steamboat that traveled from Albany during periods of high water which allowed its passage on the Santiam River.

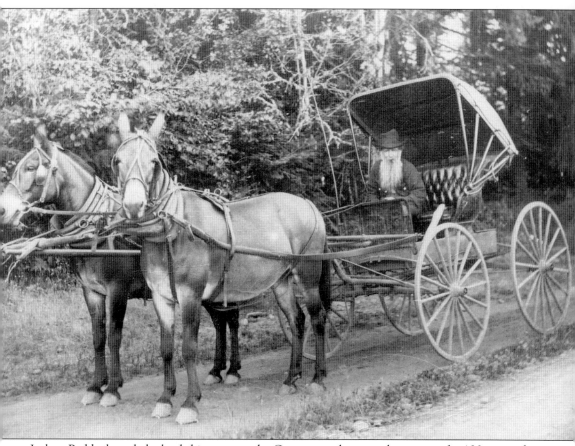

Joshua Paddock traded a buckskin pony and a German made meerschaum pipe for 120 acres of land south of Sweet Home. The land adjoined property that his father, an 1852 pioneer, had purchased from the Ames family for one Peter Schutler wagon and $300 in gold.

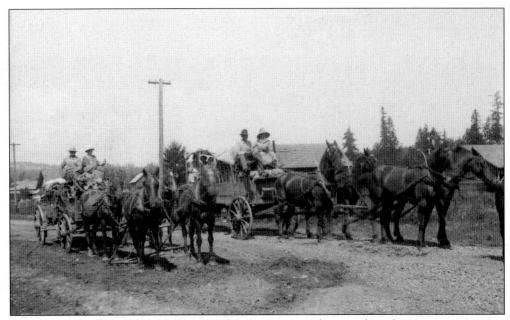

Pictured here are two wagons, each with a four-horse team. They may have been preparing to race from Foster to Sweet Home, a common form of excitement among the competitive pioneers.

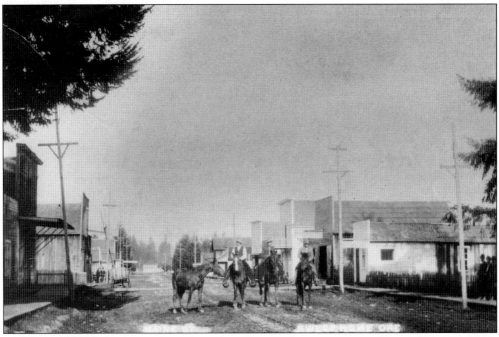

Long Street, with its improved wooden sidewalks, was the main street of Sweet Home in 1910.

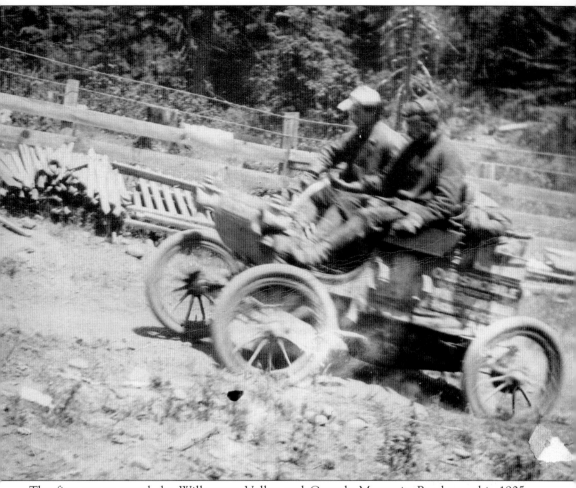

The first car to travel the Willamette Valley and Cascade Mountain Road was this 1905 Oldsmobile driven by Dwight B. Huss. Huss had to cut and tie trees to the rear of the car to hold it back coming down Seven Mile Hill. He was driving "Old Scout" in a race to the 1905 World's Fair in Portland, Oregon.

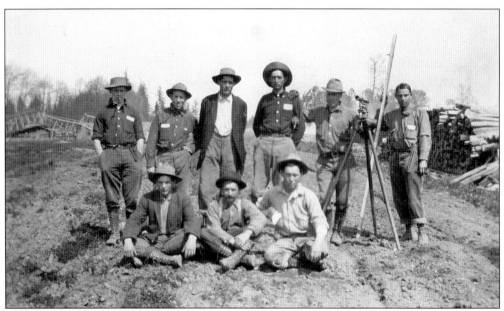

Survey crews were needed to mark logging boundaries and to lay out roads. Lloyd Rapp, Marvin Rice, and Neil Putman are among the surveyors in this photo.

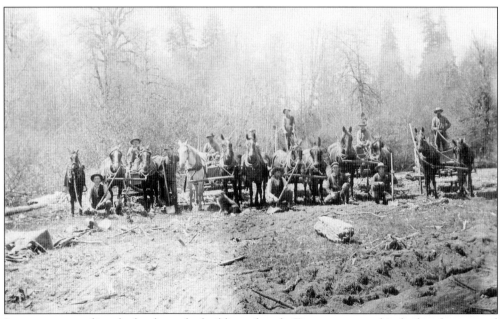

Important to settling the land was the building of roads. Five teams were hitched to these gravel wagons. The men are Roy Hildreth, Norval Rice, Charles Hamilton, (?) McQueen, (?) McQueen and R. Van Fleet.

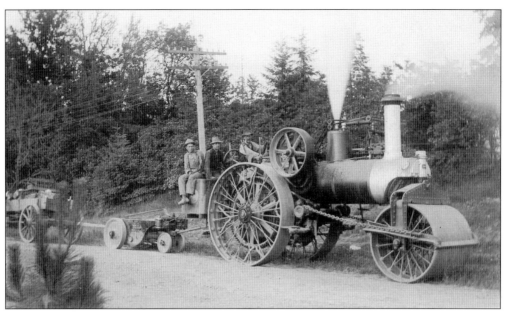

A steam engine, with rollers in the front, was used to level the gravel on a newly built road.

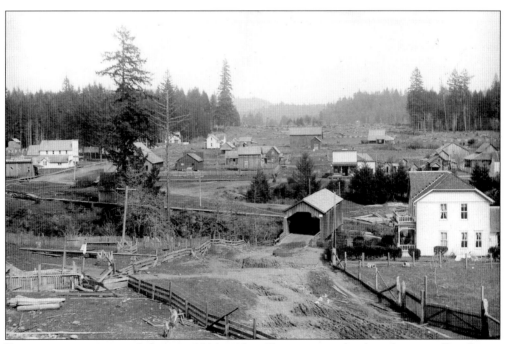

Foster was a growing settlement in 1914, with mills, stores, a school, and a post office. It was home to a large Swiss settlement that began on Sunnyside Slope near Coal Creek. These pioneers were farmers, dairymen, and cattle ranchers, and among the family names were Nothiger, Traxel, Spring, Hirschi, Stocker, and Wodtli.

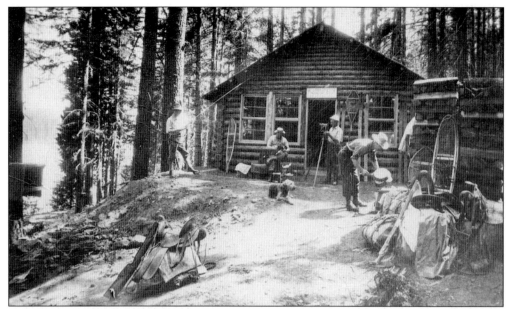

Col. T. Edgerton Hogg constructed one and a half miles of railroad track upon which a boxcar was pulled by a mule daily for over a year. This was done to hold his franchise for what he hoped would become a railroad over the Cascades. This is the survey crew at their headquarters at Clear Lake in 1912.

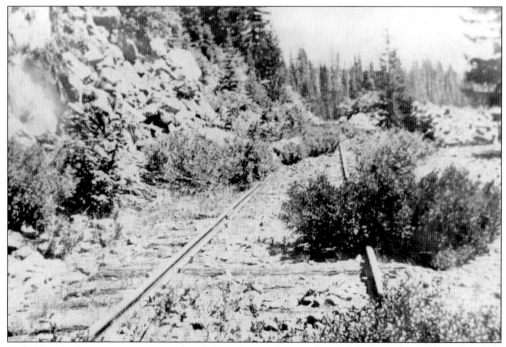

Col. Hogg's dream never materialized, but the evidence of it remains in this mile and a half stretch of railroad track.

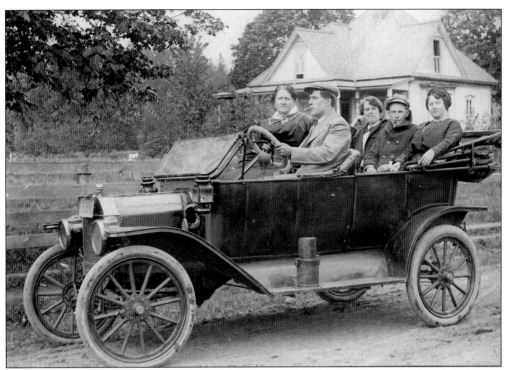

In this 1914 photo the Slavens family, Henry, Carry, Berrie, Bob, and Gabriel, are shown out for a drive in their 1913 Model T.

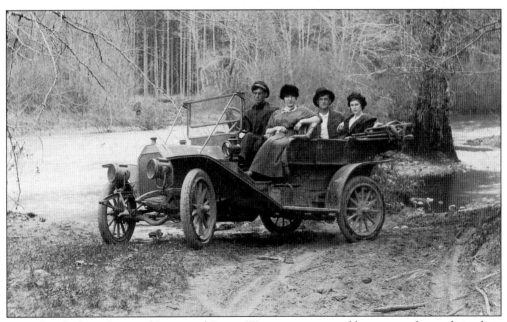

Norval and Glenn Rice and Jessie and Bessie Warner are pictured here going for a ride in their touring car.

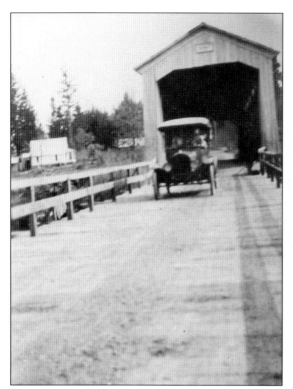

This very brave driver is crossing the Pleasant Valley Bridge in 1919. Cars were relatively new and many farmers mortgaged their farms in order to own one of these "new fangled contraptions." One farmer, who couldn't remember how to stop, hit a cow and broke her hip while crossing the bridge. The cow cost him $25, his mortgage was closed, and he lost his car.

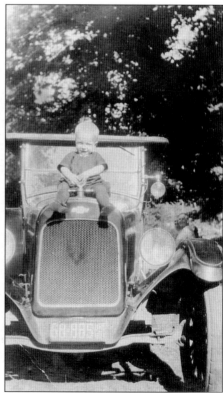

Don Menear got his picture taken while sitting on the hood of his father's car.

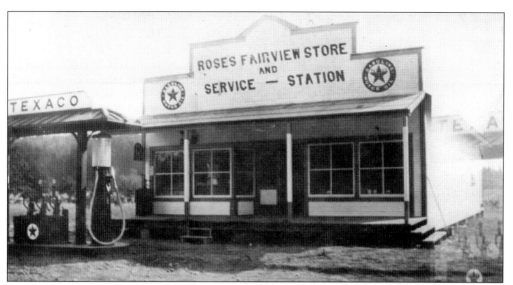

Halfway between Lebanon and Sweet Home, Rose's Fairview store and gas pump was a welcome and much needed business. This picture was taken during construction of the business.

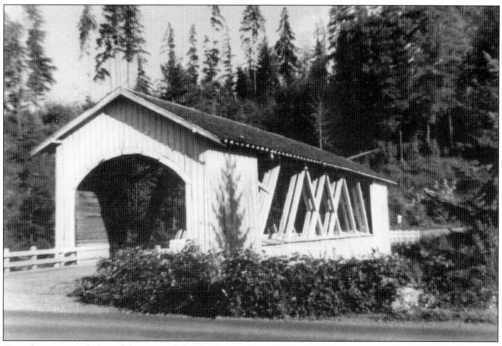

Another one of the old covered bridges was the Hufford Bridge across the Middle Santiam River above Foster.

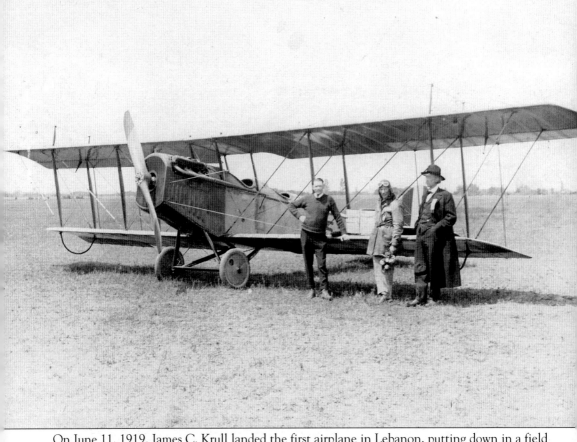

On June 11, 1919, James C. Krull landed the first airplane in Lebanon, putting down in a field along Tangent Street. He had flown from Corvallis, 18 miles away, in 30 minutes, a time lengthened by his need to fly several extra miles. Rain clouds forced him to fly southeast, circling Peterson's Butte instead of flying directly to Lebanon. Sweet Home's Dr. Robert Langmack, who owned several planes during his lifetime, was another early pilot. He made it a practice to fly over the countryside every morning watching for a white sheet placed on the ground in front of a house, a signal that someone in that home needed his help. The small landing strip east of Sweet Home is still known as Langmack field.

Four
LEARNING AND WORSHIPING

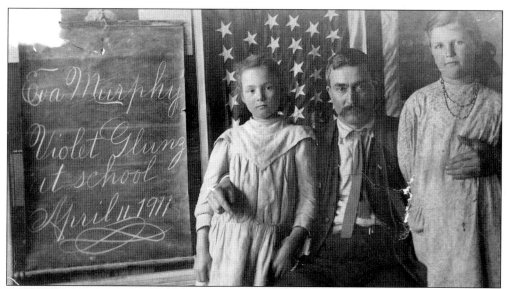

Eva Murphy, Jerry Banks (the teacher), and Violet Glunz posed for this 1911 photo. Holley School #56 was organized in 1855. It was uniquely built with a stile about 10 feet wide with up-and-down stairs to keep the animals out.

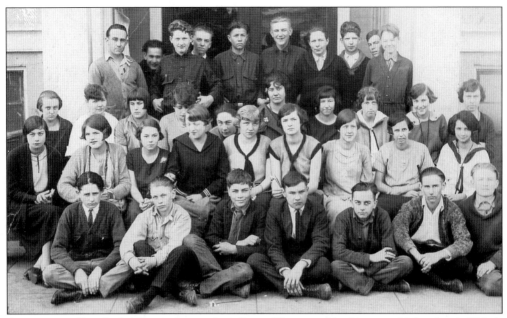

At one time Crawfordsville was larger than Sweet Home and had its own high school. This is the freshman class of 1925.

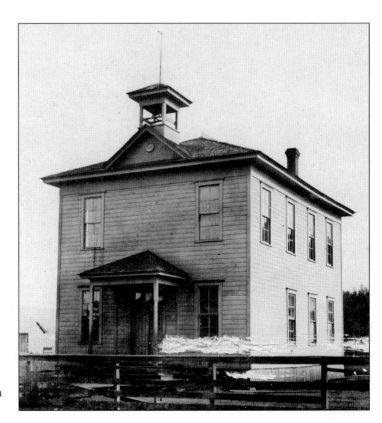

Crawfordsville, called Brush Creek District or Gouger's Neck, opened its first school in 1853. In 1892 this two-story high school was built on the present school site.

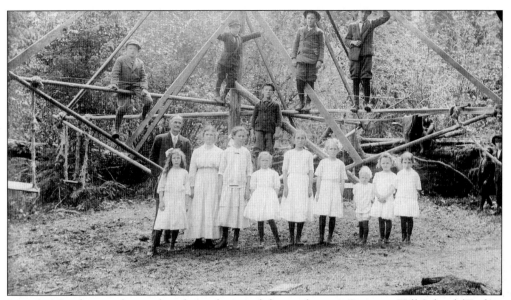

Lincoln Murphy was the teacher shown here with his students at Crescent Hill School (Turkey Shoot) #104. The school had from 6 to 15 students.

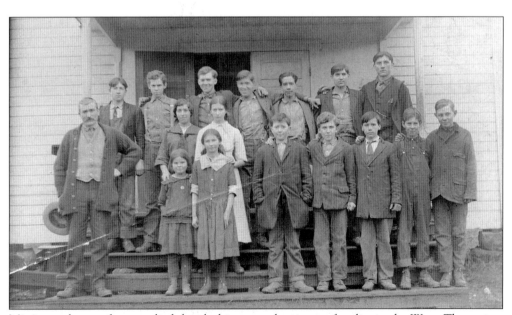

Missionary boxes often supplied the clothing worn by pioneer families in the West. The variety of styles and fit is clearly seen on this group of school children pictured with their teacher, Lincoln Murphy.

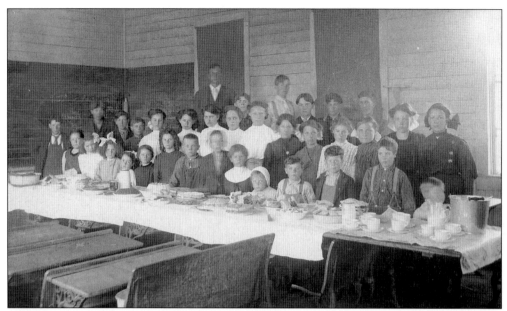

Holley School children are pictured here with their teacher, Roscoe VanFleet. Among the students are Ernest Malone, Charley Malone, (?) Hufford, Mary Hufford, Maude Waltons, Les Keeney, Henry Keeney, Sam McQueen, Wayne Groshong, John McQueen, Carl Rice, Alta Groshong, Ruth Robinson, and Millie Rice

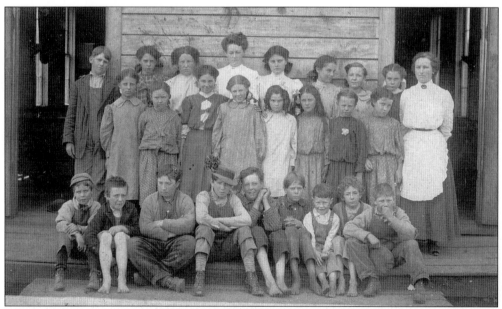

This is a photo of Holley Grade School students. For some children, the lack of shoes was cause for remaining at home instead of attending school. As you will note in this picture, other children ignored the lack of footwear and simply showed up with none.

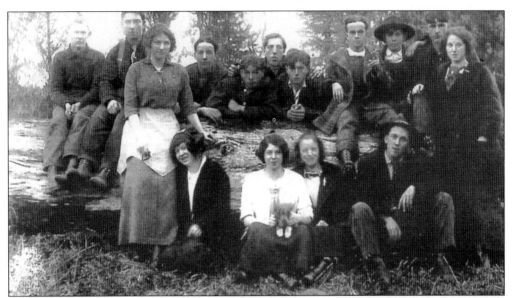

Holley School, now only a grade school, once included a high school. This picture was taken in 1915. (Courtesy of Deana Campbell)

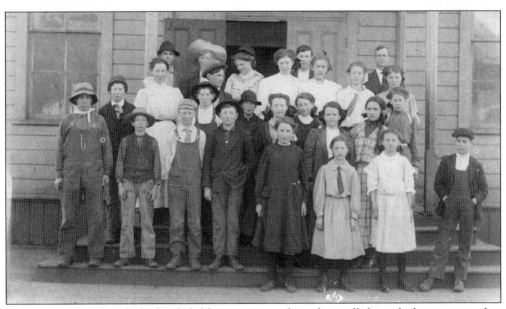

This group of unidentified school children appears to be rather well-dressed when compared to other photos of children during this same time period.

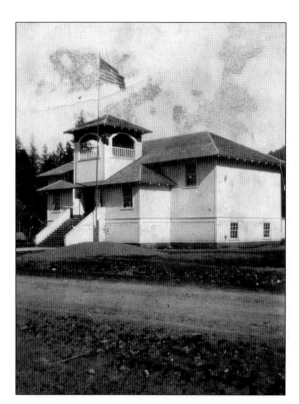

Foster School was established April 22, 1893. There have been three different schools built on the present school site. An 1898 description read, "no dictionary, not enough water, no water closets, but ample wood and good ventilation." (Courtesy of Mary Poitras.)

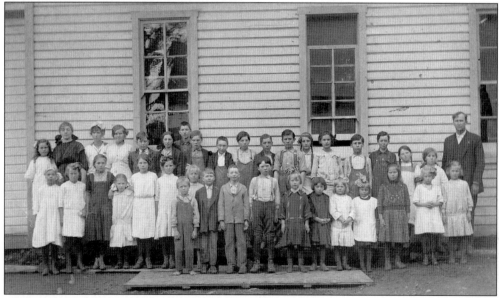

R. VanFleet is shown with his students at Foster School in 1915.

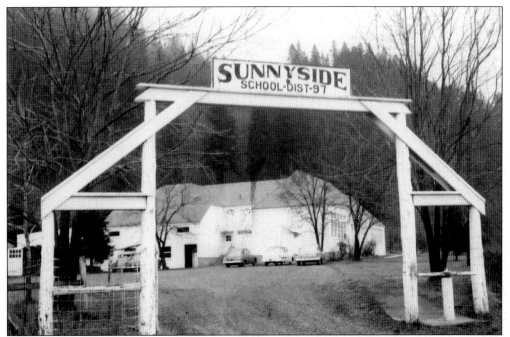

A third Sunnyside School was built on the Sunnyside Slope in 1950. When the 1904 school was built, the old school was torn down and part of the lumber hauled to Sweet Home where it was used to construct a church building on Long Street. This building is now the East Linn Museum.

The Moss Butte School was located on the old wagon road near Mealey Road House.

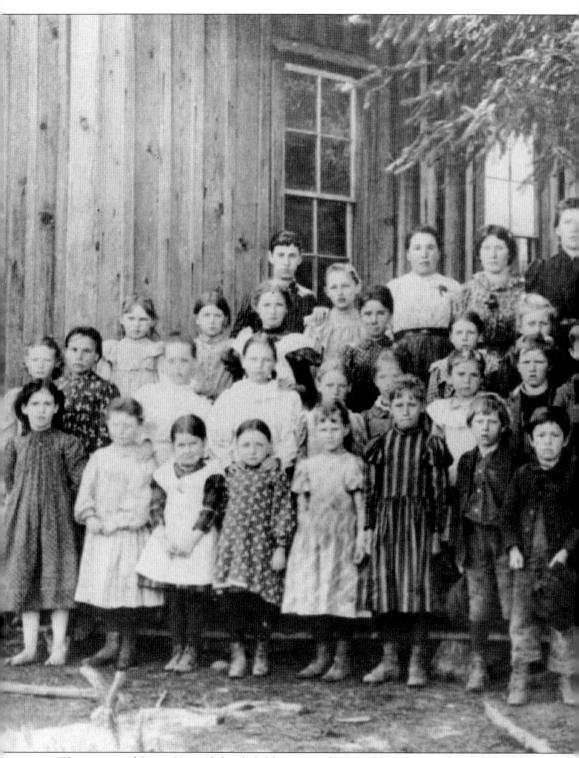
This picture of Sweet Home School children was taken in 1899. Shown, from left to right, are Grace McClure, (?) Donaca, Vera Coulter, Della Putnam, teacher Callie Bigbee, Bert Simons,

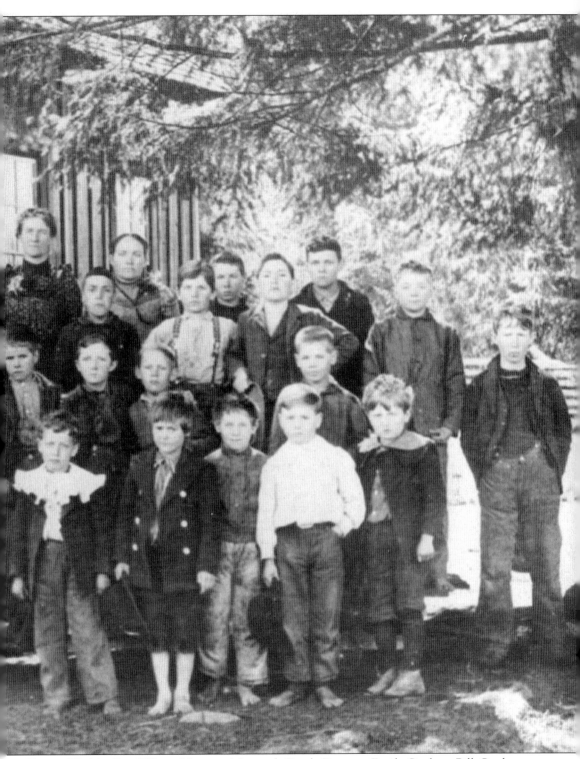

Emma Wodtli, Roy Elliott, Norman Maynard, Frank Donaca, Frank Coulter, Bill Coulter, Arthur Sportsman, Norman Miller, and Fred Simons. The other identities are unknown.

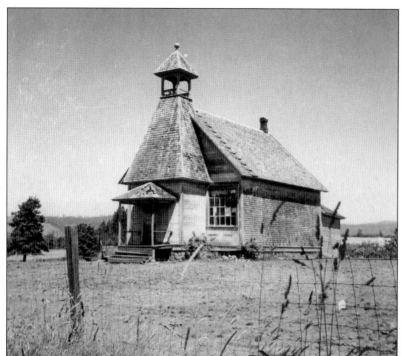

Providence School, first called Shilo School, was located one mile west of Providence Church. For several years the congregation from Providence met in the school until they could construct a church building.

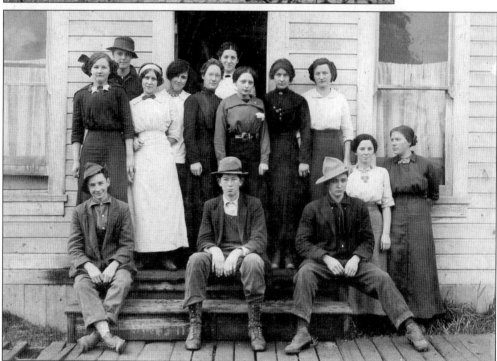

Greenville School #87 was built on the Hugh Gee Ranch in the Greenville area in 1879 when the Holley School District was split. It extended from the Narrows on present Highway 20 to include Fern Ridge and Sleepy Hollow. The second Greenville School is still standing and being used as a residence.

McDowell Creek School was in the Berlin area north of Sweet Home. Schools were within one to two miles of each other, and were generally built where the largest cluster of families lived. (Courtesy of Keith Gabriel estate)

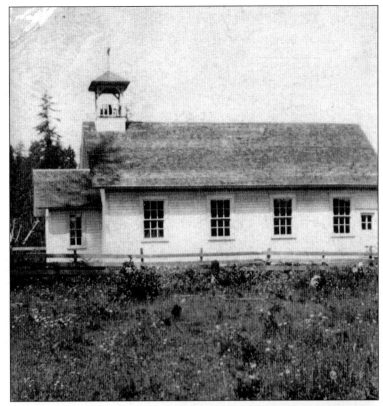

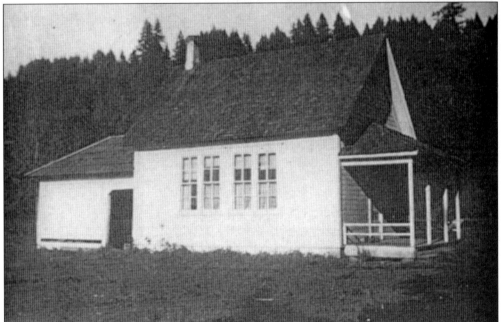

Beulah Land School was built in 1912 at the far end of Pleasant Valley, dividing the Pleasant Valley School District. It was closed in the 1940s and the children were sent to Foster School. (Courtesy of Keith Gabriel estate)

Callie Bigbee was one of the most beloved and widely known Oregon schoolteachers. Starting in 1934, an annual picnic honoring Mrs. Bigbee was held at the Sweet Home City Park, later called "Sankey Park." Mrs. Bigbee brought an old-fashioned school bell to the picnic and after dinner she would ring it and call roll. Everyone responded by relating a memory from his or her school days with her. She started teaching in 1886 and came to Sweet Home in 1898. Her starting salary was $20 a month. She taught in Lebanon, Holley, Pleasant Valley, and Sweet Home as well as in eastern Oregon.

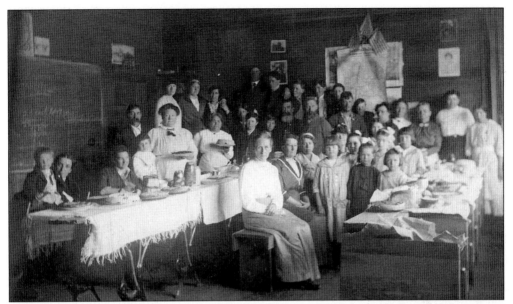

This was a last-day-of-school picnic at Pleasant Valley School in 1915. The school started in the 1870s from a log cabin near the spring on the Horner property. Ten years later a new school was built on Charles Vaughn's place. The present school site was first used in 1910. Early school children came from the Smith, Horner, Gabriel, Woods, and Burnett families.

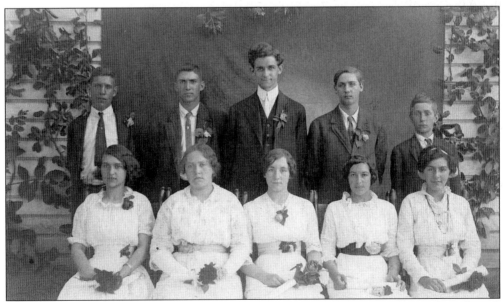

Pictured here, from left to right, is the Pleasant Valley eighth grade graduating class of 1915: (front row) Louise Geil, Millie Rice, Freida Miller, Josephine Miller, and Anna Scholl; (back row) John Miller, Milo Smith, (?) Geil, Austin Russell, and Ted Russell.

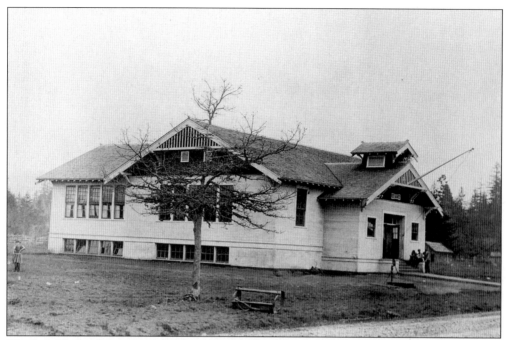

The fourth school to be built in Sweet Home was this grammar school built in 1922 on Long Street. The building was located near the present School District #55 Central Office.

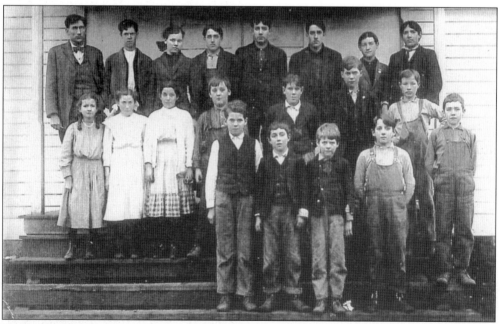

The second Sweet Home grammar school was built in 1882 on the Gilliland/Foster Road (Long Street) about one mile east of town. (Courtesy of Deana Campbell)

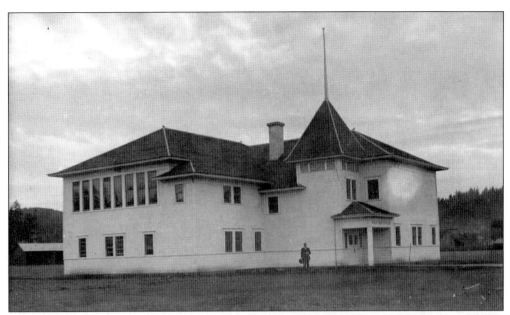

This is the Sweet Home Union High School as it appeared in 1925. The new building cost $4,000. Roscoe VanFleet was principal and teacher and received $60 a month. When it was discovered that he was only certified to teach grade school, James Thompson and an assistant, Barbara Harper, were hired. In 1925 Mrs. Floy K. Hammond was honored as the first woman principal.

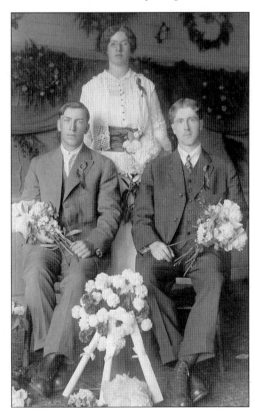

Sweet Home High School's first graduation was in 1915. The three graduates were Everett McClun, Opal Russell, and Roy Wood. The second graduating class, in 1916, had only one student, Ross Davis.

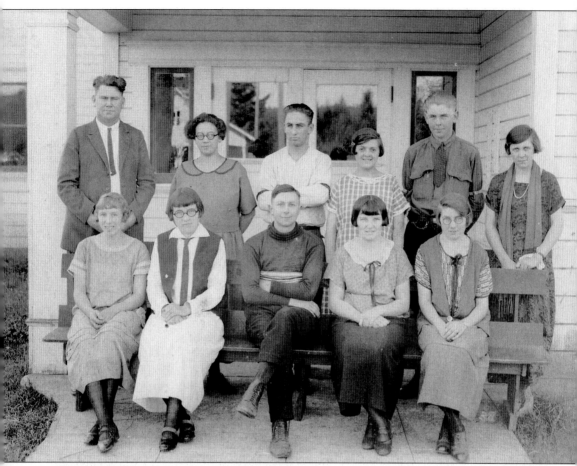

This was the 1925–26 graduating class from Sweet Home High. Pictured, from left to right, are: (front row) Elsie Weed, Merlie Hurt, Earl Wodtli, Oleatha Rice, and Lois Robnett; (back row) teachers S.D. and Joyce Stevens, Eugene Ellis, Edith Cole, Randolph (Buss) Robnett, and teacher Cleona Hull. (Lois Robnett Rice was the founder of the East Linn Museum.)

Santiam Academy in Lebanon was started in a log cabin in 1852. Funds were raised by subscription to erect a two-story, four-room schoolhouse, co-educational but without boarding facilities. Completed in 1855, by 1864 105 students from as far as 200 miles away were attending. Graduates Arthur Cree and George Ross from the class of 1900 are pictured here.

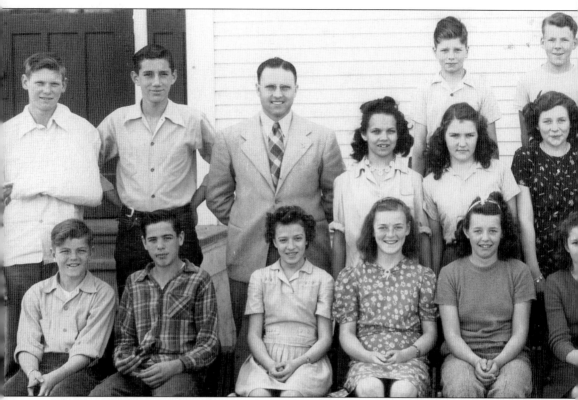

The Sweet Home seventh grade class of 1946, from left to right, were: (front row) Lloyd Powell, Don Seiber, and Evelyn Hipp; (second row) unidentified, Jack Monroe, Otto Walber, Ruby Fogerson, Delores Curtis, Myrna Mitzentine, Virginia Sims, Shirley Hall, Gloria Manns,

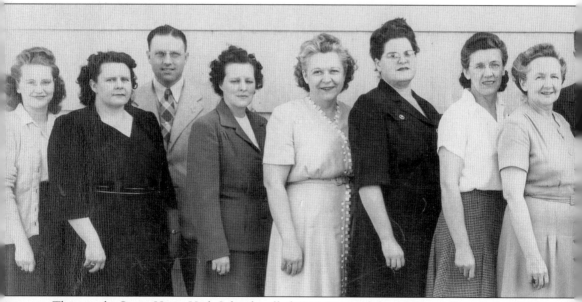

This was the Sweet Home High School staff of 1946. Pictured, from left to right, are: Annabelle Berger (office), (?) Childs, Otto Walberg, (?) Sprague (principal's wife), Myrtle Caswell, May

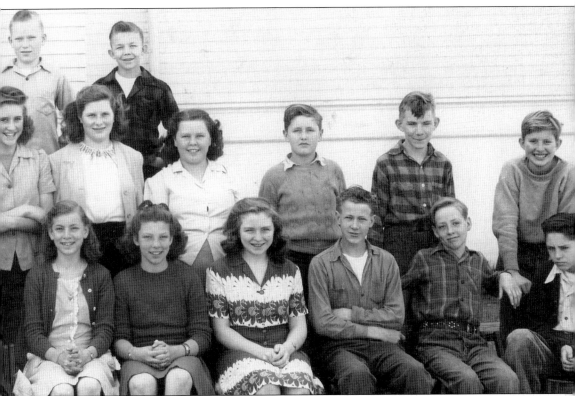

unidentified, Merlyn Hall, and Howard Schroll; (third row) unidentified, Ray Kelley, Ronald Alanen, and Jim Leatherwood.

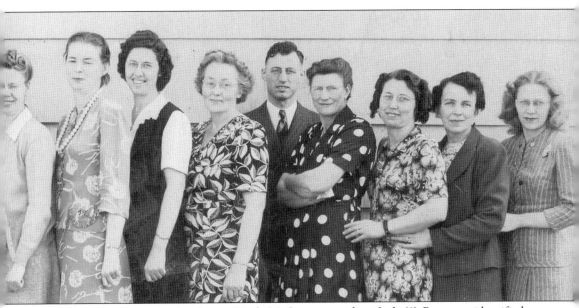

Lundholm, Ida Keeper, Esther Jones, Hugh McQueem, unidentified, (?) Bangs, unidentified, Laura Redmond, (?) Lind, Doris Latimer, (?) McClure, Donna McQueen, and unidentified.

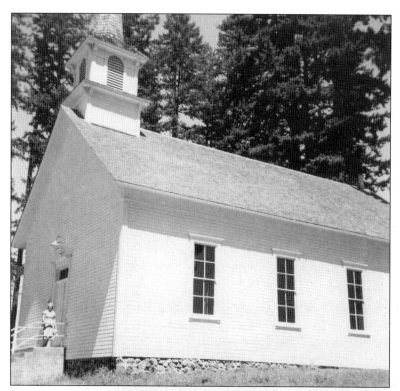

Providence Church, completed in 1898, is one of the few remaining church buildings in continuous use. Joab Powell, famous Baptist minister and circuit rider, proclaimed the gospel all over the Pacific Northwest. This church was built and used by him. He also built churches in Pleasant Valley, on Fern Ridge, and in Holley.

His faithful Baptist followers erected a monument to Joab Powell and 19 charter members of the Providence Church. As a visitor to the state legislature he was asked to be the chaplain for the day. He gave the shortest and most pertinent prayer ever offered, "Lord, forgive them for they know not what they do. Amen"

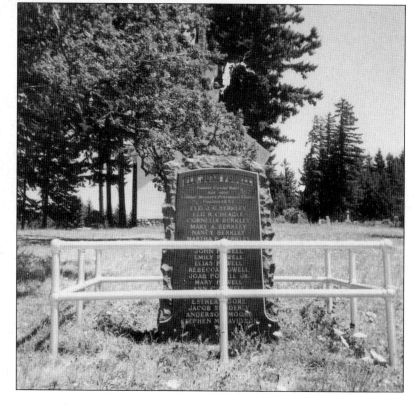

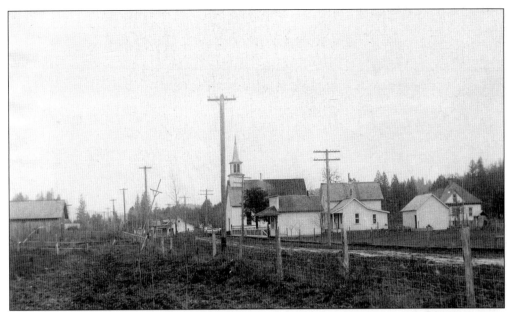

Originally called the Upper Church, the Church of Christ is still located at 18th and Long. In 1912–13 it housed the high school. Jacob Stocker, a Swiss emigrant, was the first minister and was also a teacher at the high school. J.C. Banks took this photo, looking east on Long Street, in 1914.

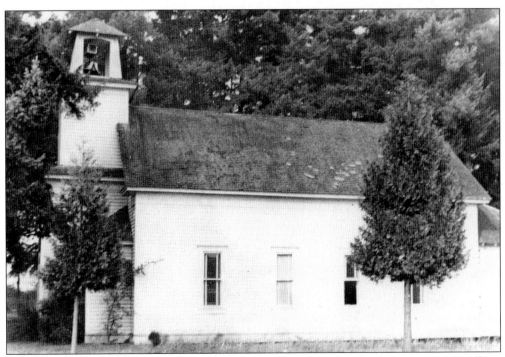

The Holley Christian Church started meeting in 1871 in the Splawn School House. William Matlock sold two acres, more or less, for $5 to William Fields, T.A. Riggs, and N. Shanks on which to build a church building, with the provision that it was to be used continuously as a church. The church building was completed in 1875–76 and has never closed.

In 1904 property was purchased from the Cumberland Presbyterian Church in Lebanon, across from the Santiam Academy, and St. Edward's Catholic Church was started. The Catholic priest served Catholics in Sweet Home and the surrounding area. The old church was torn down and a new, modern building now serves Lebanon.

In 1878 a Presbyterian Church was built in Crawfordsville. Before that Rev. William Blain organized a group of people under the precepts of the Associated Reformed Presbyterian Church. The first meeting was held at the home of Mr. and Mrs. John Courtney on Courtney Creek, June 18, 1849.

Five
WHO WERE THEY?

Lowell and Polly Ann Ames were among the first settlers in Sweet Home. Trying to find a new home in order to escape persecution for their Mormon faith, Lowell led a wagon train of family and friends to Oregon Territory. Lowell and Polly had six sons and one daughter. He and four of the sons took up donation land claims on what is now the business section of Sweet Home.

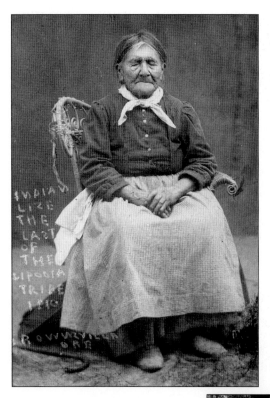

At one time the Kalapooian tribes had as many as 8,000 members, but by 1851 there were only 560 families of the Kalapooia and Santiam Indians living in Linn County. In 1856 these were moved to the Grand Ronde Indian Reservation. Indian Lize, pictured here, was the last of the native Kalapooian to live in Linn County. She died at the age of 114 and is buried in Brownsville.

The Indian Council Tree is located on the Nye donation land claim in the Liberty area. Kalapooia Indians gathered there and the men conducted their business while the women dug and roasted the winter's supply of camas bulbs. The tree, reported to be 400 years old, is still standing. Nearby is the burial place of Chief Black Hawk of the Kalapooian.

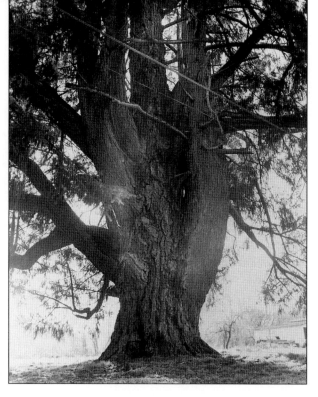

McCagey Moss and his family arrived in Sweet Home in 1852. He filed a donation land claim on 320 acres, 5 miles west of Sweet Home. Moss Butte bears his name. He was a hunter of great renown and his favorite gun was said to have a crooked barrel so that he could shoot around the Butte and bring down his deer on the other side.

Sarah Ann (Carroll) Moss made dresses out of identical fabric for her and her daughter, Polly Ann. McCagey and Sarah raised nine children: John, Zealy, William, Stephen, Hiram, Almirah, Polly Ann, Reuben, and Bradley.

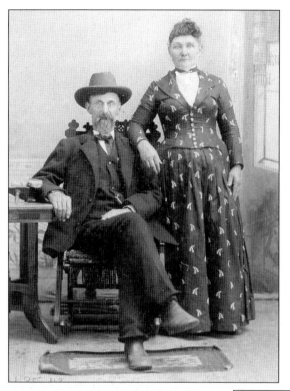

Zealy Bluford Moss married Emaline Barr. He owned and operated Sweet Home's first general store and saloon, named Buckhead. The small community around it was known by the same name. Further east, at 18th and Long, his father operated a store around which grew the community of Mossville. Later these two communities joined to become Sweet Home.

Thomas and Eliza Ann (Weddle) Malone raised their family in the Holley area. Both came from pioneer families that had arrived in 1852. Tom's father was the area banker, hiding his money in the ground. To obtain a loan, "customers" visited the banker and negotiated the terms, then, if successful, returned the following day to pick up their money. In this way the "bank" remained a secret.

Samuel D. Pickens was the third son of William and Sarah Pickens who came from Ohio in 1847. He settled, with his family, in the Foster area along the Santiam River.

These are five of William and Sarah Pickens's children: Orlando Pickens, Adeline Pickens Furman, Geneva Pickens Lewis, Hattie Pickens Rice, and George Pickens. All nine of their children married and settled in the area. The first baby born in the area was a Pickens baby, born March 14, 1869.

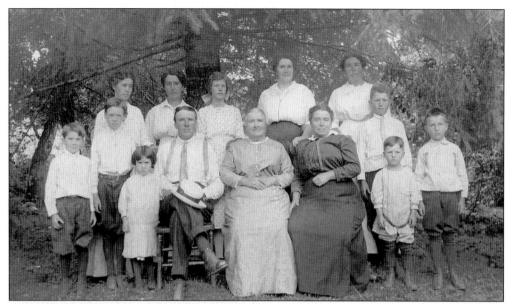

The Putnam family, James and Mary Ellen and five children, came to Sweet Home in 1880. Son Bill was an early stagecoach and freight driver between Lebanon and Sweet Home. Identified here are "Aunt Ellen," Bill, Hattie Putnam Roth, Susie Putnam Paddock, and Della Putnam Davis. Bill died in 1918, two years after his father's death.

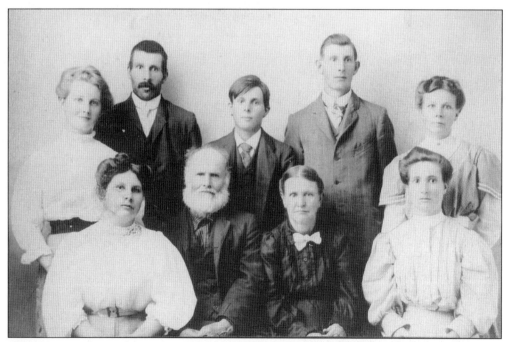

This is a 1908 photo of the pioneer Newton family of the Brush Creek area. Pictured are Samuel C. and Mary (Rebukan) Newton, Ivy Newton Miller, Hattie Newton Kenmen, John Newton, Will Newton, Ralph Newton, May Newton Smith, and Sarah Newton Fleshman. Ralph drown in 1912 during a logging operation on the Calapooia River, one-and-a-half miles below Holley Bridge.

William and Mary Clark came to Foster in 1906. These three girls, Bessie Olive Clark Lewis, Fern Hilda Clark Menear, and Hattie Mable Clark Warner, were the oldest of their 15 living children.

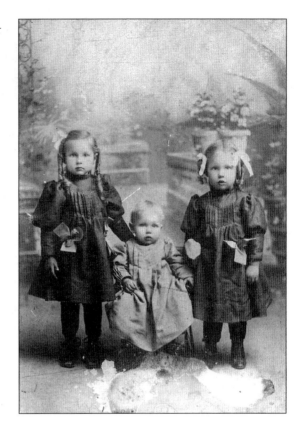

Jacob and Emma Menear came to Foster in 1890. They operated a roadhouse on the old Wagon Road four miles east of Foster for many years. Emma was famous for her apple pies. Jacob laid out the town of Foster, offering a real deal—two lots for the price of one—but there were no roads leading in or out of the village. (Courtesy of Mary Poitras)

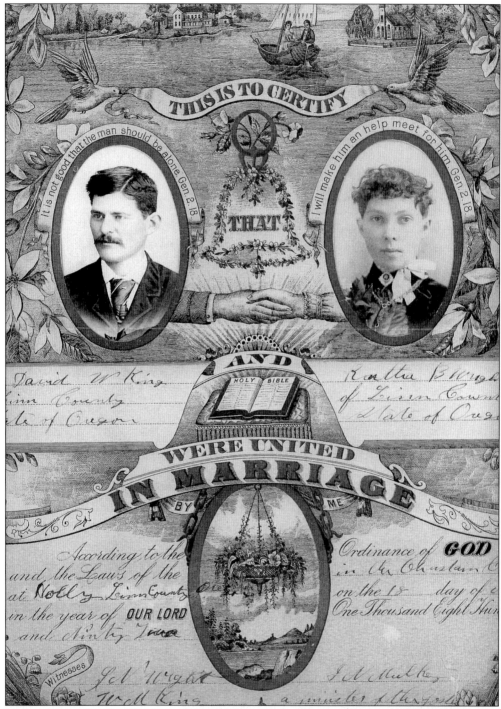

The wedding of Rutha Wright and David King was the first wedding held in Holley Christian Church, May 18, 1892. Rev. I.N. Mulkey came from Eugene to perform the ceremony, which came as a total surprise to the congregation that had gathered for a special mid-week service. (Courtesy of Deana Campbell)

Charles M. Kendall and his family came to Albany in 1905. On October 12, 1911, he was appointed deputy sheriff and served for eight years. In the fall of 1918 he was elected sheriff of Linn County by the largest vote cast for any man or measure in the election. He was widely known as an advocate of temperance. He was re-elected for a second term in 1920.

C. M. KENDALL For Sheriff

I have supported the Republican party for over twenty-five years—have never held a public office and never asked for a single political favor until I made the race for sheriff in 1916.

I stand squarely on the right side of all moral questions and I shall sacrifice neither principle nor patriotism nor the ineterest of Linn county for politics.

We are in this war and no one can forecast the probable cost to this country in men and money. Every American citizen is expected to "make good" and as I am past the draft age I must do my part here.

I am in this campaign, primarily, for the purpose of giving my boy a high school education and doing everything I can for the boys who are in the service.

I want to win this time, if I can do so honorably, and I am prepared to do my duty as an officer of the law.

I was chief deputy in the office for over eighteen months and I have served as a peace officer and outside deputy at different times for 10 years.

My record is clean. My accounts were accurate. I never made a false arrest, never failed to get the man I went after and never lost a prisoner.

In case of my election in November I shall run the office strictly according to law.

I shall give prompt, efficient and accommodating service at all times.

I shall keep the office expenditures as low as possible and I shall turn over to the Linn County Red Cross all rewards collected for the arrest of slackers.

C. M. KENDALL
Republican Candidate for Sheriff

Primary May 17—1917

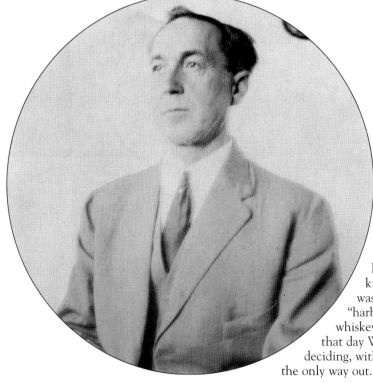

On June 21, 1922, Sheriff Kendall and Rev. Roy Healy went to the Dave West farm near Plainsville to serve a warrant. West was reported to have a still on his property. Kendall and Healy were shot and killed by West after he was placed under arrest for "harboring moonshine whiskey on his property." Later that day West killed himself, deciding, with his wife, that that was the only way out.

Knowing that he would be buried in Nebraska, Peter Rapp planned a rehearsal funeral. He wrote his service, got his pallbearers and coffin, and set up the church and minister. He then invited all of his friends to Holley Christian Church where he sat in the back and watched his own funeral. (Compliments of Lucille Rapp)

George and Jerry Keeney were the twin sons of James and Susan Swank Keeney and grandsons of Jonathan Keeney, a noted frontiersman, Rocky Mountain trapper, miner, rancher, and captain of Company C 2nd Oregon Volunteers. George and Jerry were known for their roles as law enforcement officers in Sweet Home and also served as state game wardens. Paid by the number of arrests they made, they became very unpopular.

Six
FROM HUNTING TO MUSIC

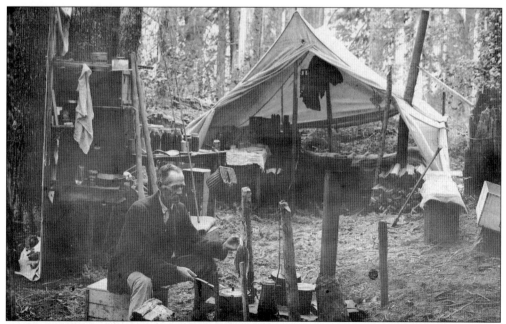

Lincoln Murphy, an early Sweet Home teacher, is shown vacationing at Clear Lake in the Oregon Cascades in this 1911 photo. Clear Lake, a favorite camping spot for over 150 years, is just south of the old Wagon Road that crossed the Cascade Mountains.

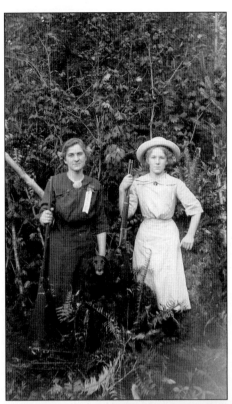

The Goodwin family settled half-way up Green Peter Mountain. The girls in the family had to learn how to hunt along with the men. Here Libby and Eliza are pictured with their guns ready for a hunt.

Cougars were plentiful and posed a threat to the farmers' livestock. Pictured here are the results of one hunting party. John Newton, John Crocker, Wes Cochell, and Cleve Cochell pose with their hunting dog and three cougars.

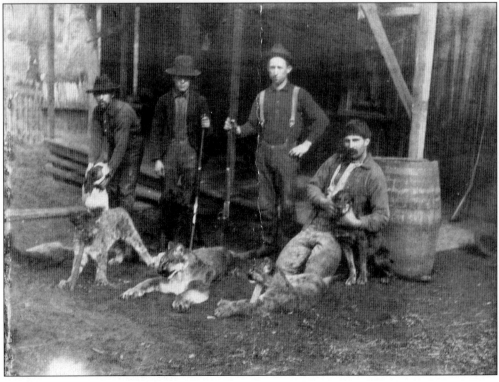

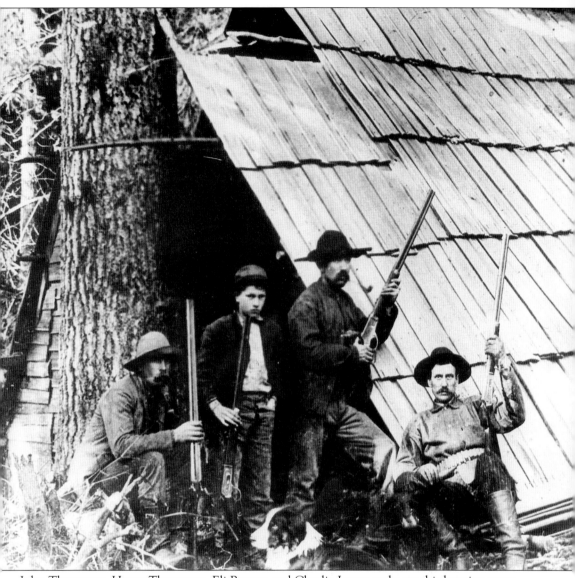
John Thompson, Henry Thompson, Eli Ramer, and Charlie Lyons make up this hunting party in the Swamp Mountain area above Sweet Home.

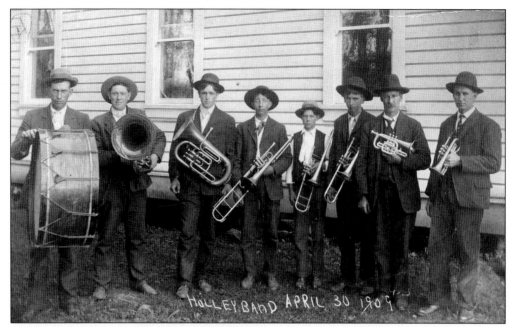

The Holley Band of 1909 was composed of Frank Splawn, Fred Malone, Charlie Malone, Harley Hamilton, Oren King, Vern Philpott, George Lowery, and Roscoe Van Fleet.

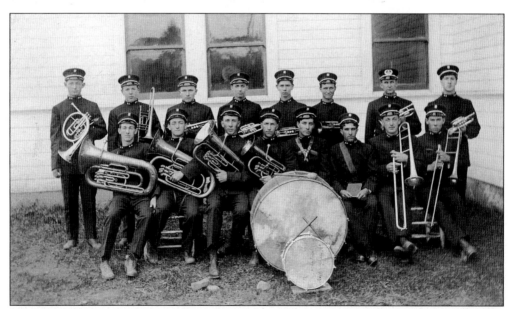

The 1916 Sweet Home Union High School band was the pride of the community. Bake sales and various other fundraisers were held to buy the band uniforms. Pictured, from left to right, are: (front row) Russ Davis, Fred Davis, Jim Morehead, Everett McClun, Everett Smith, Jay Wilkins, Roy Elliot, and Lester Morehead; (back row) Lloyd Harris, Harvey Thompson, Ernest Scholl, Austin Russell, Carl Russell, Frank Davis, Prof. Van Fleet, and Ray Woods.

The South Santiam River is famous for its trout, steel head, and salmon. Cousins Ray Riggs and Glen Peck are heading home with two large fish hanging from a pitchfork. Early fishermen could stand on a bar in the river and spear their fish with this tool.

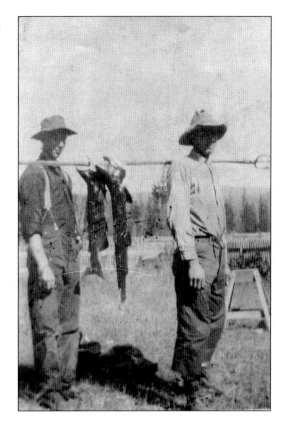

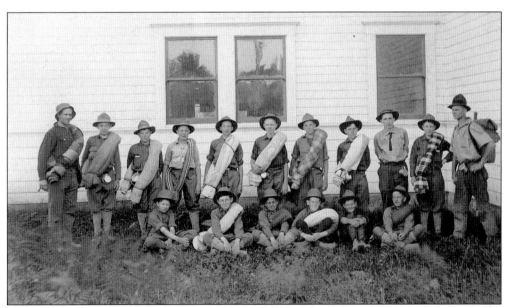

A group of Boy Scouts with their bed rolls are ready to leave for a camping trip. Five different presidents honored Sam Cairnes, a Sweet Home Scout leader for more than 50 years, for his leadership in Scouting.

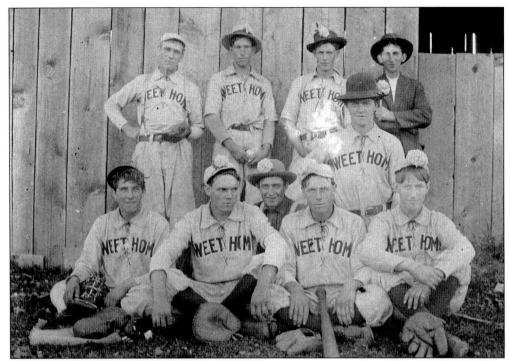

The 1907 Sweet Home baseball team, from left to right, was: (front row) Jay Wilkins, Arthur Sportsman, Roy Hanchett, and Harve Davis; (back row) Henry Lawrence, Bill Brewer, Floyd Hanchett, Ed Storey, and Bill Downing.

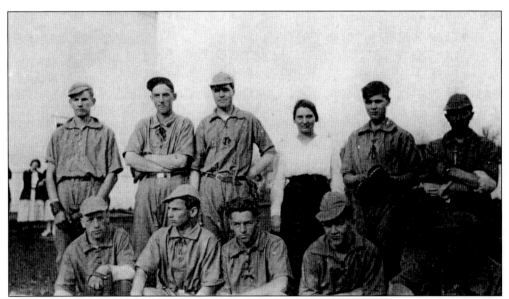

Sweet Home has always had a baseball team. The first woman high school principal, Flay Krone, stands proudly with this team in the 1920s. Pictured here, from left to right, are: (front row) Eddie Simons, Eugene Ellis, Carl Rice, Clifford Rowell, and David Mealey; (back row) Earl Reinhart, James Geil, Robert Forster, Leon Blankenship, and Earl Wodtli. (Courtesy of Keith Gabriel estate)

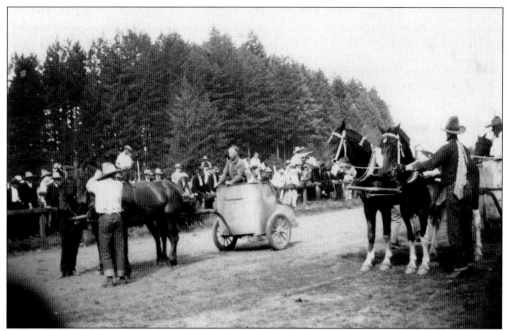

Community Fair days in Sweet Home were the big event of the year. This is a July 4, 1927, picture of an unidentified participant in the chariot races.

BROWNSVILLE TIMES
LINN COUNTY, FRIDAY, JULY 6, 1923

Crawfordville Celebration Attracts Many From Here

A fine lineup of attractions and ideal weather combined to make the attendance at the 4th annual round-up and celebration at Crawfordsville Wednesday the largest in the history of the association. Crawfordsivlle and upper Calapooia residents were out en mass and Brownsville, Halsey, Harrisburg, Albany and Lebanon were all well represented. As early as nine o'clock the streets fronting the grounds were parked to capacity with cars and the stream continued to arrive until afternoon.

The principal event of the morning was the parade, headed by mounted officers of the association followed by the band and a large concourse of mounted men and women in gala attire typical of the west. This was at 10 and at 10:45 occurred the cowboys and girls mounted grand march.

At 11:30 a program of foot races and kindred sports was pulled off—and then the big feed. Picnic parties dotted the park in all directions and for considerable distance up and down the river on either bank.

The drawing card of the celebration was the roundup features held in the arena at one o'clock and the big racing program which followed. Exhibitions of steer and mule riding bareback and horse riding with all the accoutrements of the cowboy were held. The racing program filled the balance of the afternoon. The track was in fine shape and some interesting records were set up in the various classes.

Refreshment booths and amusement enterprises were not lacking and the management bent every effort to make the day of interest.

Directors of the 1923 roundup were: President, D. F. McKercher; secretary, Elmer Henderson; treasurer, J. G. Dennis; finance, Grant Pirtle; grounds, I. E. Wimer; sports, Jim Smith; Indians, Mac Moss.

A list of the winners in all events is being prepared by the secretary of the association and will be available for publication next week.

The July 6, 1923, *Brownsville Times* carried this account of the fourth annual roundup and celebration at Crawfordsville. A parade was followed by foot races and other races, and then a picnic. The afternoon was taken up by bronco and steer riding, barrel races, and, the main attraction, horse racing. Visiting Warm Springs Indians had very good ponies and were eager to race the White men.

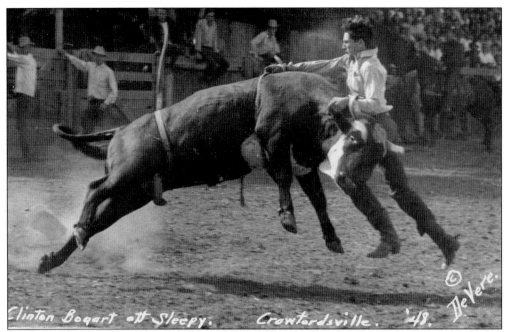

The Crawfordsville Rodeo drew contestants from near and far. Clinton Bogart is ending his ride on Sleepy in the 1948 rodeo.

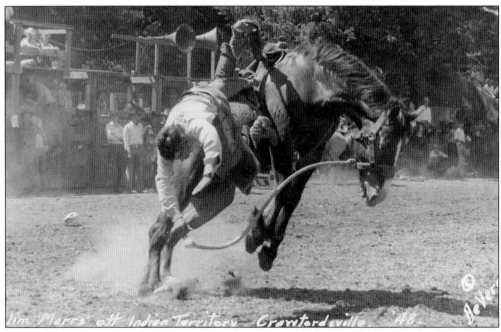

One more buck and Jim Marrs will part company with Indian Territory. Many cowboys chose this hard way to make their winter expenses as they followed the rodeo circuit.

Fourth of July meant stars and stripes, and Coleman Carlyle decorated his bike with them for the Community Fair where patriotism, with lots of speeches and flag waving, followed the parade.

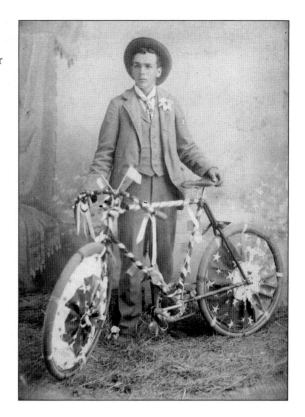

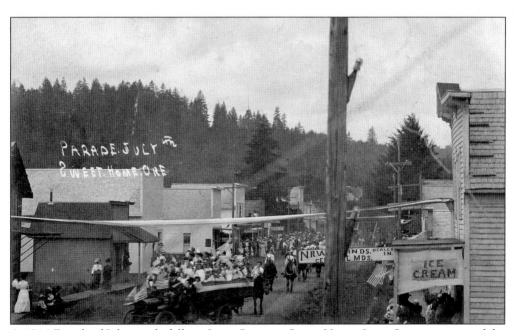

A 1914 Fourth of July parade follows Long Street in Sweet Home. Long Street was part of the Old Wagon road heading east.

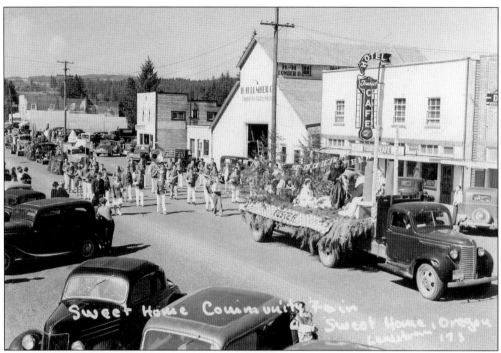

By 1940 the main street though Sweet Home had changed to Highway 20 and the parade followed this route.

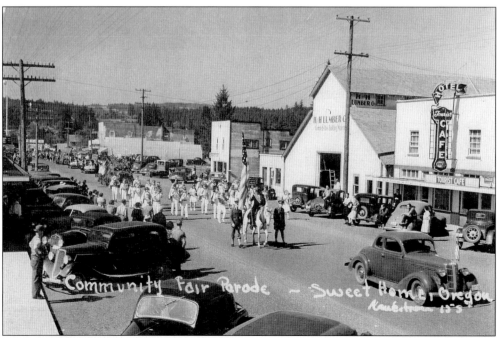

What began as the Community Fair became Frontier Days, and then Sportsmans Holiday, but one never changing scene was the parades.

Seven
Places to Remember

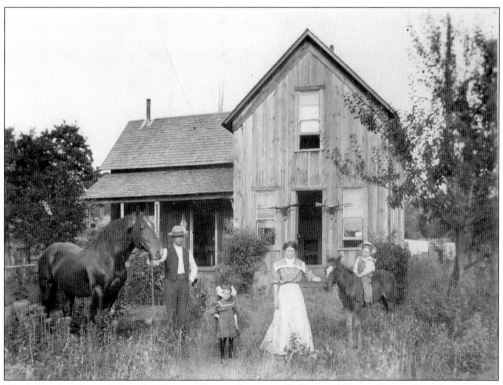

The Moss family settled in the Greenville area between Holley and Sweet Home. Standing in front of their home are father Jess Moss, Fay Moss, Verna Wilkins Moss, and Ray Moss on the pony.

This house, built on Long Street in 1910 by Jack Keeney, is still standing. Pictured are Jack Keeney, Dean Keeney, Chesley Keeney, Zillah Ames Keeney, and Zillah's mother, Isabelle Ames.

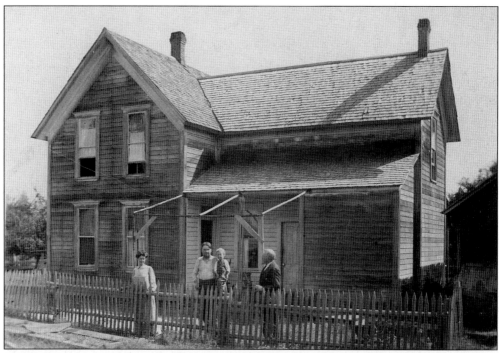

Childhood diseases are not always limited to children. Standing in front of the old Andrews house is Mae Putman, Will Putman with the mumps, Neal Putman, and Dr. Luther. Dr. Luther had a sure cure, a "30-30" laxative that he freely prescribed—"a mild form of dynamite" guaranteed to put the "go" to the most stalwart citizen and keep them from complaining about non-existent ailments.

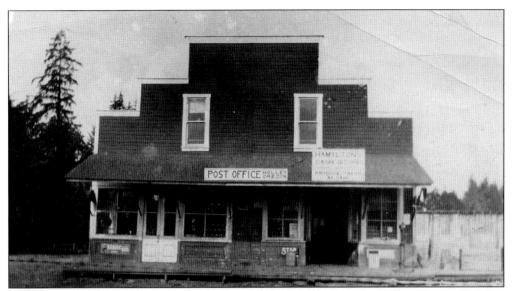

At one time Holley had a store, post office, blacksmith shop, dance hall, and school. Asher Hamilton tried farming, but his first love was the mercantile business. He and his brother-in-law opened the Pioneer Store in Sweet Home, but after six years he returned to farming. He tried a store in Holley for four years, returned to farming, and then in the fall of 1900 again opened his store in Holley.

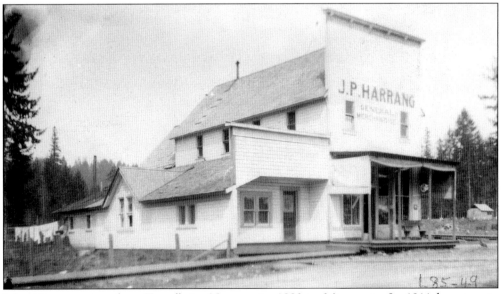

John Harrang came from Trondkein, Norway, in 1880 to Minnesota. In 1911 he came to Oregon and bought 135 acres at $35 an acre from the Oregon and Western Colonization Company through their agent, N.J. Nye. The railroad was supposed to come through Foster, but when those plans fell through he purchased the general store owned by Daniel Brady Jr. He and his family operated this store for several years.

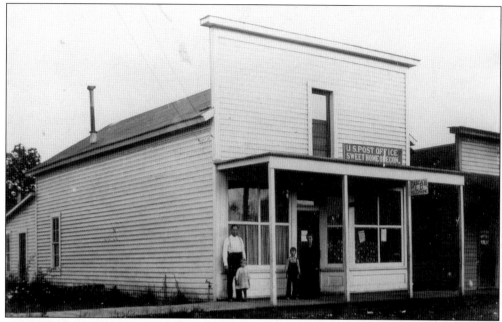

Sweet Home got its first post office on March 13, 1874. Before that, mail was delivered by horseback. The location changed several times but the post office stayed, continually serving the citizens of Sweet Home. Standing here are early teacher Roscoe VanFleet, Annie VanFleet, Roy VanFleet, and Leatha VanFleet.

At the time of this photo Adella Gabriel was postmistress of the Cascadia Post Office. Her husband worked at the Cascadia Ranger Station. George Geisendorfer opened the first post office in 1898. In 1940 the state of Oregon bought the Geisendorfer property and made it into the 300-acre Cascadia park. (Courtesy of Keith Gabriel estate)

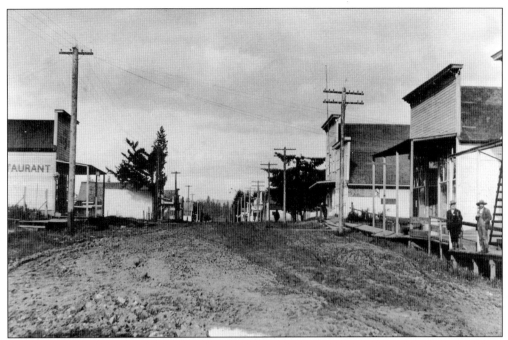

This is a view of Long Street looking east. The boardwalks were built on posts so as to be above the mud in the rainy season. At one time they also hid a stash of liquor, which a group of boys discovered. After opening the bottles and pouring out the liquor, they turned the bottles in to obtain some extra pocket money.

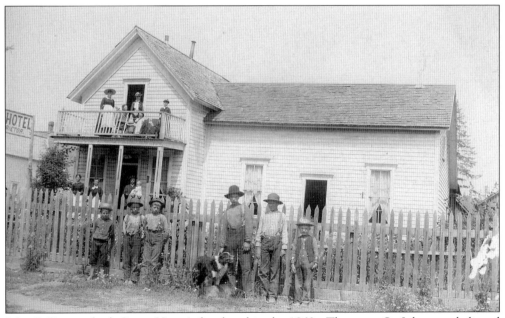

John P. Donaca built Sweet Home's first hotel in the 1860s. The name St. Johns was believed to have been taken from his first name. It was adjacent to the old Willamette Valley and Cascade Mountain Road near what is now 10th and Main. It was destroyed by fire in 1912.

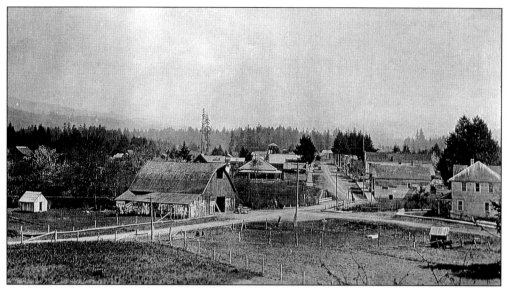

Looking east from the present Oak Heights, Zealy Moss's barn and livery stable can be seen at the Ames Creek Bridge. The Independent Hotel, built in the 1870s, is on the right. Travelers were charged 25¢ for a bed and 25¢ for a meal. Some would have been miners heading to the Quartzville mines, and perhaps other travelers on the Old Wagon road. (Courtesy of Keith Gabriel estate)

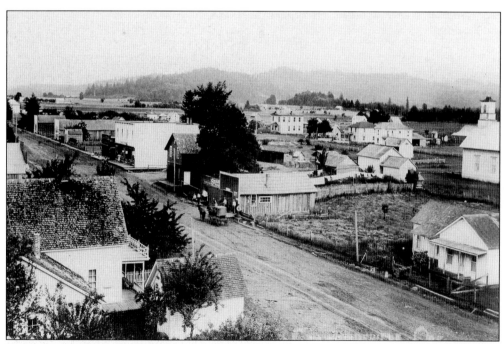

In 1912 Crawfordsville was a busy village larger than Sweet Home. Philemon Crawford purchased 10 acres from Timothy Riggs and Robert Glass to build the town. The deed was written such that if any intoxicating liquor was sold on those 10 acres, the property immediately reverted back to Riggs and Glass. By 1870 a flourmill, sawmill, shoe factory, and steel knife factory were in operation.

The Davis home was on Long Street across from the Nazarene Church, now the East Linn Museum. Shown are Ida Rachel Davis, Warren Harvey Davis, Sarah Eliza Brugler Corven, and Stella Davis Parker. (Courtesy of Deana Campbell)

Jake Rollin's furniture factory was located on the banks of Ames Creek. It was an important business in the community, producing wicker chairs and rockers.

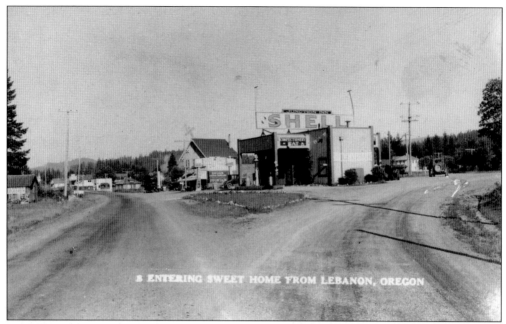

This picture was taken at the junction of the Lebanon/Sweet Home road and the Brownsville road. Called the "Y," it was also where Long Street ended. The "welcome" sign was removed when the Shell service station was built.

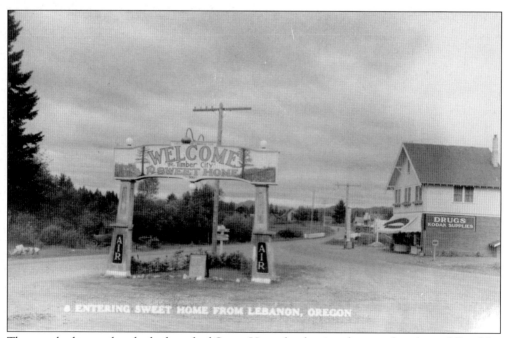

The traveler knew when he had reached Sweet Home by the sign that stood in the middle of the "Y." Sweet Home was called "Timber City" by many and deserved its nickname; all were welcome.

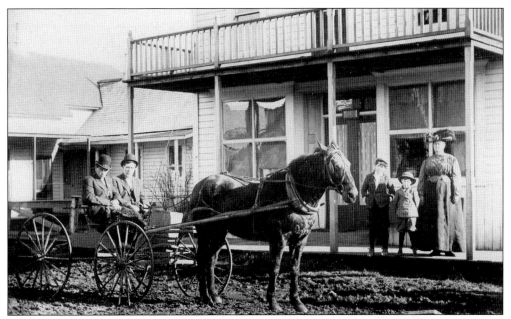

It was unusual to have a female funeral director, but Rhett Slavens ran the funeral parlor and her husband, Henry, had the blacksmith shop. Shown in front of the funeral parlor are Henry Slavens, an unidentified man, Rhett Slavens, Joe Slavens, and Wilkie Slavens.

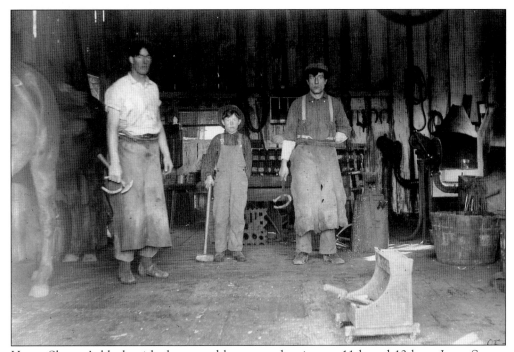

Henry Slavens's blacksmith shop stood between what is now 11th and 12th on Long Street. Harrison Robinett, Joe Slavens, and Henry Slavens are ready to shoe a horse. This is where the men gathered to discuss politics, farming, and life in general.

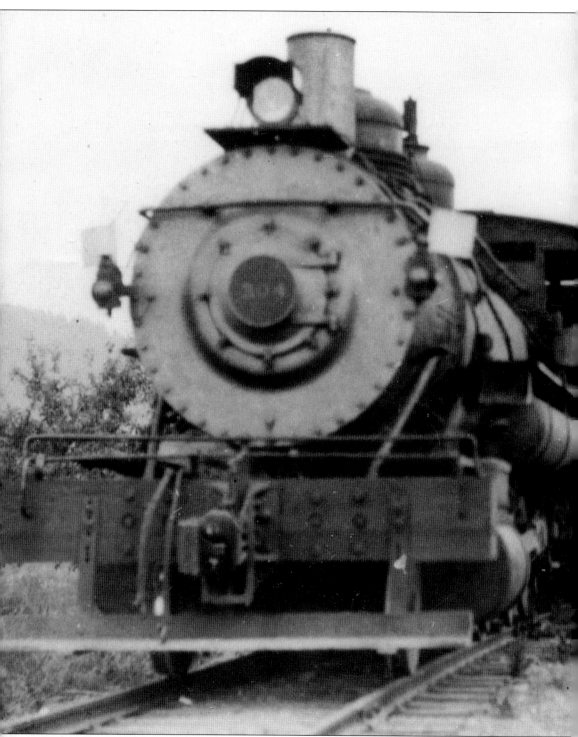

It was a gala day in Sweet Home when the first train rolled in. Four crowded coaches and a private car carried 639 people from Lebanon to Sweet Home where a welcoming delegation served them strawberry short cake, whipped cream, and lemonade. The golden spike was gilded by Alvin

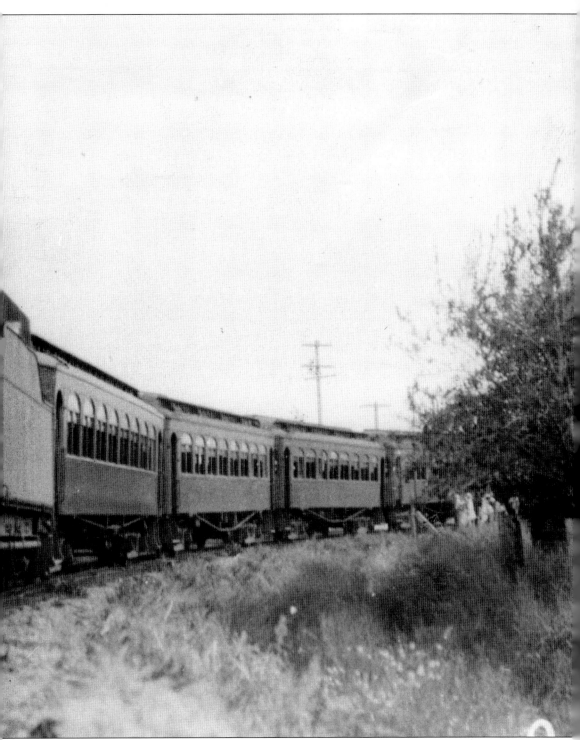

Russell and driven in by Marvin Nye. The train was actually intended to haul logs and traveled across the valley to Dollar Camp, seven miles above Holley. The sound of that train, with its load of logs, traveling day and night, is still a vivid memory to some Sweet Home residents.

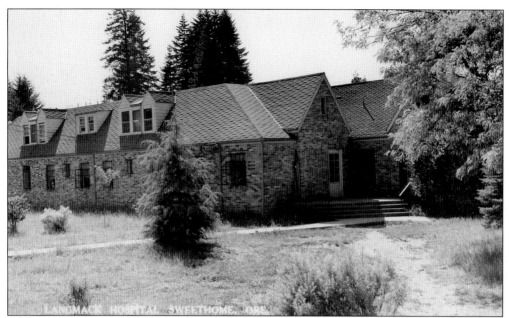

Dr. Robert Langmack and his wife/nurse, Hester Beard Langmack, came to Sweet Home in 1931. He dreamed of a hospital closer than Lebanon, so in 1945 the 35-bed Langmack Hospital was opened at the junction of Highway 20 and Highway 228. Today this is the East Linn Medical Center and the doctors still use the hospital in Lebanon. (Courtesy of Keith Gabriel estate)

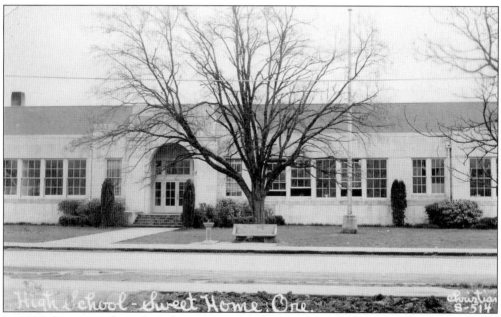

In 1916 the one graduate from Sweet Home High School was Ross Davis. The locust tree in front of the school was planted in his honor and was known as "Toot's Tree," his nickname. The high school has undergone many changes and additions since 1915 but it is still in the same location. (Courtesy of Keith Gabriel estate)

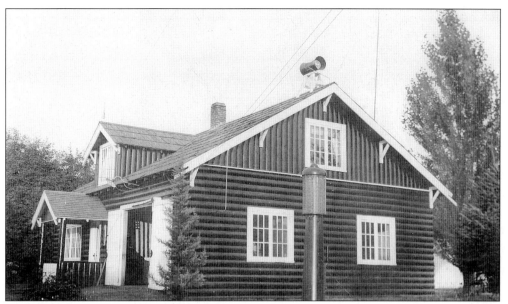

In 1939 Marvin Nye offered to furnish the city a house, free of charge, to be used as a firehouse for the fire fighting equipment. For $30 a month he would act as fire marshal and select his own squad of firemen. The city council purchased a small double head siren for $300 to alert the volunteer firefighters that the fire department was in operation. (Courtesy of Keith Gabriel estate)

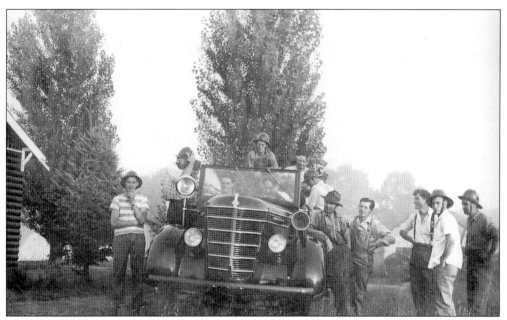

The first volunteer fire crew consisted of: Chief N.J. Nye, Captain Earl Williams, Bob Jenkins, Gordon Norstrom, Harley Munch, Charles Anderson, Ross Davis, Emil Davis, Henry Kayenski, Roy Minch, Jack Gilbert, Dan Martin, Harold McMannama, Clyde Scott, and Ivan Hoy. The Nye house was used until 1945, when the firehouse was moved to Long Street property owned by Lloyd and Floyd Rapp. (Courtesy of Keith Gabriel estate)

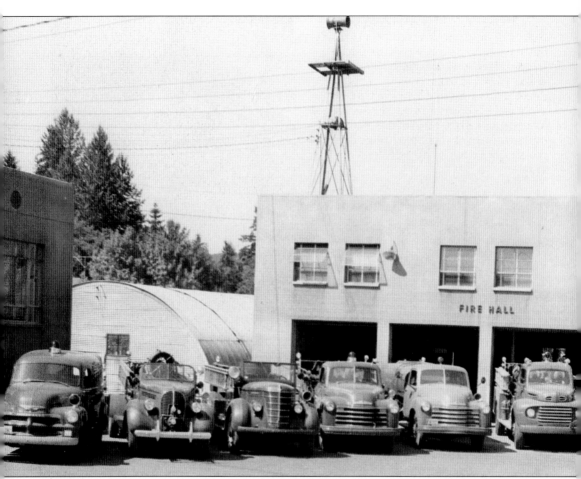

The second fire hall was soon out of room and a Quonset hut, made of steel, was acquired in 1947. In 1954 a new fire station was built and the Quonset hut was moved to the back of the lot where it was used as a strut shop making room for the new city hall. By then the number of volunteers had increased to 35. (Courtesy of Keith Gabriel estate)

Letty Thompson Sankey and her daughter, Audrey Bryant, were descended from a family that took the responsibility of citizenship seriously. Letty told of her grandfather walking two days to cover the 10 miles to Sweet Home so he could vote for Grover Cleveland in 1888. As a joke, her own father, John, placed Letty's name on the ballot for mayor of Sweet Home and she was elected. She served two terms, 1929–1930.

This picture, taken about 1930, is of the City Hall and Police Station after it was remodeled during Letty Sankey's term as mayor.

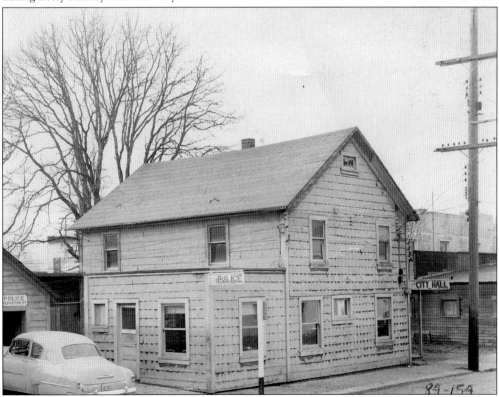

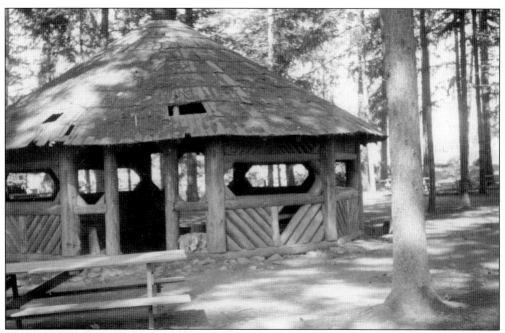

This city park was built in 1938–39 and was widely used and well known across the country. It was later named Sankey Park, after W.S. Sankey, long time councilman and civic leader. Four acres of land purchased for $500 from John Wodtli provided the land for the park.

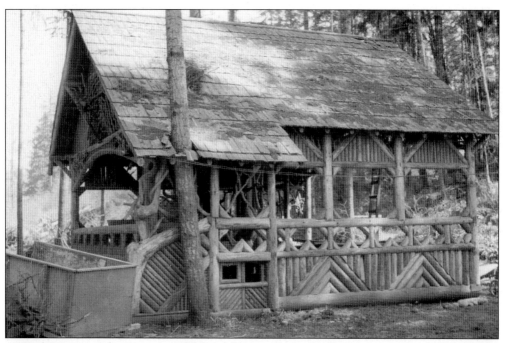

A Work Progress Administration (W.P.A.) Project during the Depression years of 1938–39, the building of Sankey Park provided much needed work. Riley Thompson directed the construction of the covered bandstand, pavilions, and other buildings. He had built log cabins for a Montana dude ranch and used that rustic style in the park.

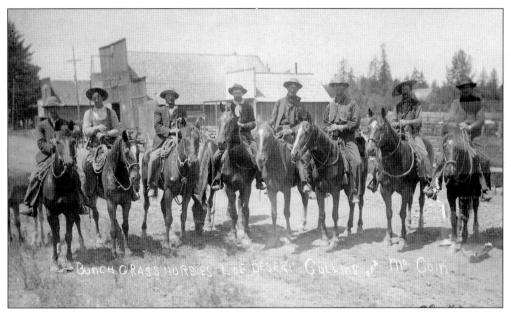

Hundreds of bunch grass horses were rounded up in eastern Oregon and brought over the pass to be sold. Wild horses grazed on the natural forage and hence the name, "Bunch Grass." These eight horses are shown after being broke to ride.

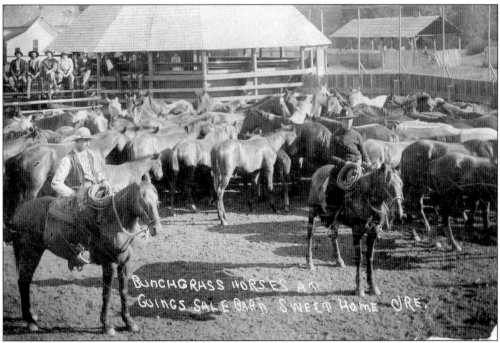

Henry Goings and his son, Warren, built a modern feed, livery, and sale barn in 1906. Located across the street from the present city hall, they had a big corral with an enclosed, round sales ring with seats. A fee of 25¢ was charged to see a bronc busted. Many Sweet Home men worked on both sides of the Cascades, rounding up the stock, driving them over the mountains and breaking them.

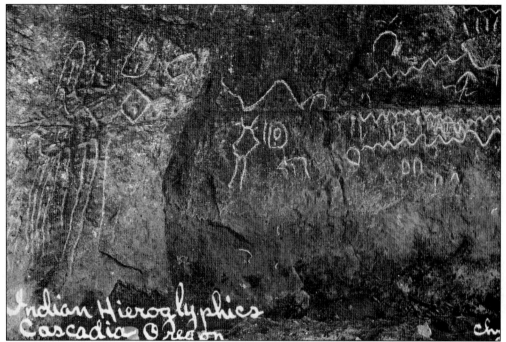

Ancient petroglyphs may be seen on a cave above Cascadia. One theory on their meaning is that they were directions for an old Indian trail which followed the Cascade crest from Mt. Hood to California. It is believed that an earlier tribe than the Kalapooians was responsible for these writings, possibly dating back 10,000 years. (Courtesy of Keith Gabriel estate)

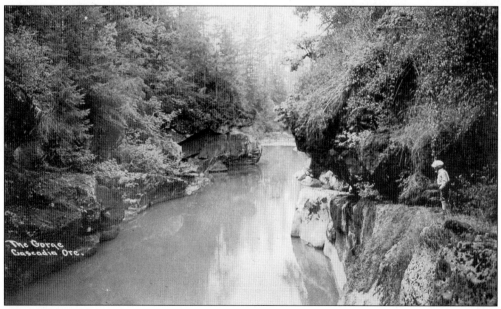

The trail leading to the Cascadia Indian Caves rises above the South Santiam River. Still noticeable are the signs of cooking fires and the smoke on the rocks from council fires. (Courtesy of Keith Gabriel estate)

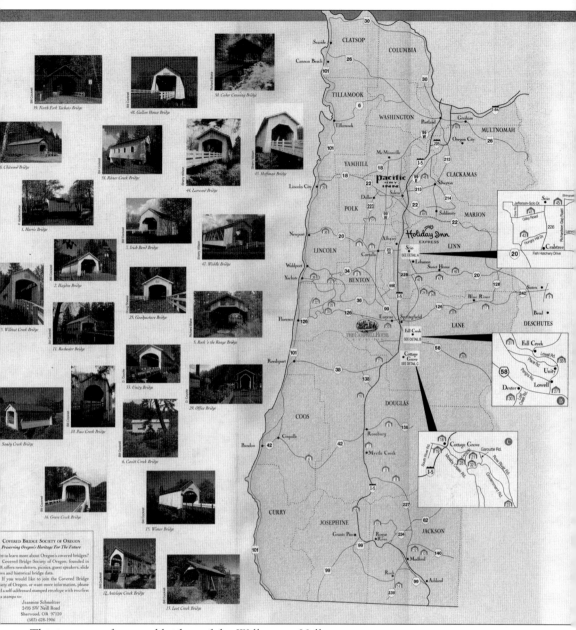

This is a map of covered bridges of the Willamette Valley.

123

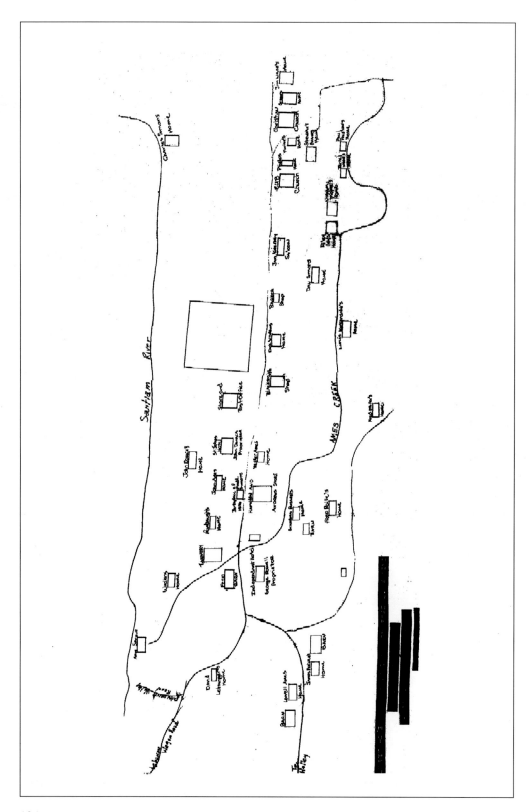

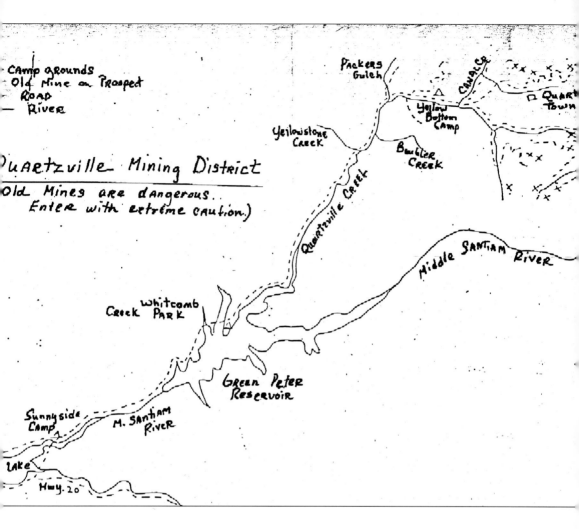

(*opposite page*) Fred L. Simons drew this map of Sweet Home in 1893. William E. Simons had been postmaster of Sweet Home from 1879 to 1881.

The Fir Has Claimed His Own

by William Mealey

The sturdy fir stands where the mill once stood
The screaming saws no longer tear through wood,
No tireless steam no longer turns the wheel
No scent of fresh sawn wood, no flashing steel.

The sawyer does not stand before his saws
The deckman with his lines, no longer draws
The dripping logs from out the murky pond.
Dead silence wraps the old mill-site around.

No exhaust from the laboring engine throbs
No mill crew toiling at their various jobs
All, all is silent—on the littered ground
The wreckage of the burned mill lies around.

William Mealey (1870–1948) was known as the Poet of the Santiam and often used the pen name, "Santiam." His writings included over 200 poems and articles, one of which was included in the World's Fair Anthology. He made his living in ranching, mining, and timber, and he witnessed the devastating loss resulting from the frequent mill fires that occurred during the logging boom in Sweet Home. He also typified the resilience of this community, rebuilding his own burned-out mill with courage and determination, to succeed as a businessman and member of the growing settlement which has become Sweet Home.

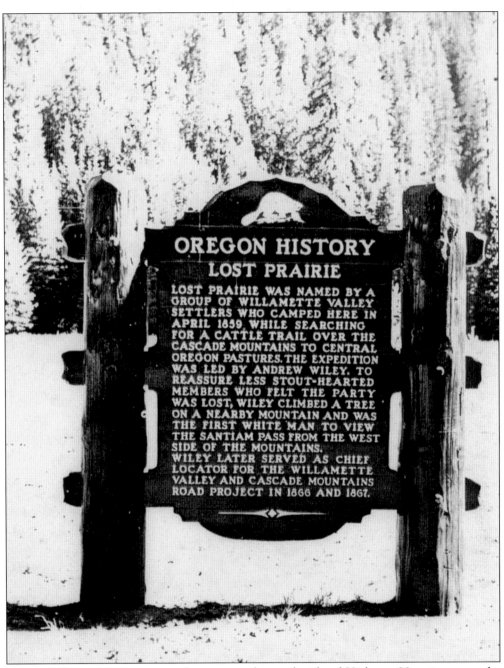

The Lost Prairie Monument can be seen on the south side of Highway 20 as it crosses the Santiam Pass between Sweet Home and Sisters. Andrew Wiley lived at the foot of the Cascades, east of Sweet Home. A tributary of the South Santiam River, Wiley Creek, was named after him.